W9-CPD-479

Complete Guide to
Digital Printing

ROB SHEPPARD

EPSON Complete Guide to Digital Printing

Book Design and Layout: Sandy Knight
Cover Designer: Barbara Zaretsky
Front and Back Cover Photographs:
Daisy field on printer and screenshot photographs © Rob Sheppard
Pink flower, boats, lighthouse, and cornfield panoramics © Joseph R. Meehan
Wedding party © Jan Press Photomedia, Livingston, NJ
Baby portrait © Jack Reznicki
Photographs: © Rob Sheppard unless otherwise specified
Product photographs: provided courtesy of the manufacturers
Editorial Assistance: Delores Gosnell

Library of Congress Cataloging-in-Publication Data

Sheppard, Rob.
 Epson complete guide to digital printing / by Rob Sheppard. 1st ed.
 p. cm.
 Includes index.
 ISBN 1-57990-427-0 (pbk.)
 1. Epson printers. 2. Digital printing. 3. Image processing—Digital techniques.
 4. Images, Photographic—Data processing. I. Title: Complete guide to digital printing. II.
 Epson (Firm) III. Title.

 TK7887.7 S48 2002
 686.2'3--dc21

 2002040797

Second Edition

10 9 8 7 6 5 4 3 2

Published by Lark Books, a division of
Sterling Publishing Co., Inc.
387 Park Avenue South, New York, NY 10016

© 2004, Rob Sheppard

Distributed in Canada by Sterling Publishing,
c/o Canadian Manda Group, One Atlantic Ave., Suite 105
Toronto, Ontario, Canada M6K 3E7

Distributed in the U.K. by Guild of Master Craftsman Publications Ltd., Castle Place,
166 High Street, Lewes, East Sussex, England BN7 1XU
Tel: (+ 44) 1273 477374, Fax: (+ 44) 1273 478606
Email: pubs@thegmcgroup.com, Web: www.gmcpublications.com

Distributed in Australia by Capricorn Link (Australia) Pty Ltd.,
P.O. Box 704, Windsor, NSW 2756 Australia

The written instructions, photographs, designs, patterns, and projects in this volume are intended for
the personal use of the reader and may be reproduced for that purpose only. Any other use, especially commercial use,
is forbidden under law without written permission of the publisher.

Every effort has been made to ensure that all the information in this book is accurate. However, due to differing
conditions, tools, and individual skills, the publisher cannot be responsible for any injuries, losses, and other damages
that may result from the use of the information in this book. Because specifications may be changed by the manufacturer
without notice, the contents of this book may not necessarily agree with changes made after publication.

If you have questions or comments about this book, please contact:
Lark Books
67 Broadway
Asheville, NC 28801
(828) 253-0467

Manufactured in China

All rights reserved

ISBN: 1-57990-427-0 (1st Edition) 1-57990-586-2 (2nd Edition)

Complete Guide to
Digital Printing

ROB SHEPPARD

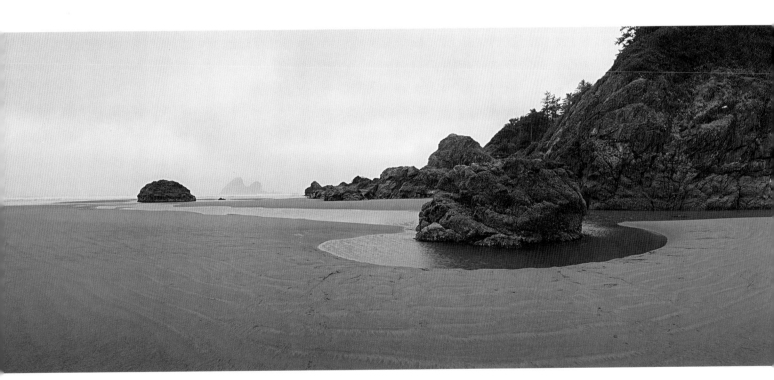

© Joseph R. Meehan

LARK BOOKS

A Division of Sterling Publishing Co., Inc.
New York

Contents

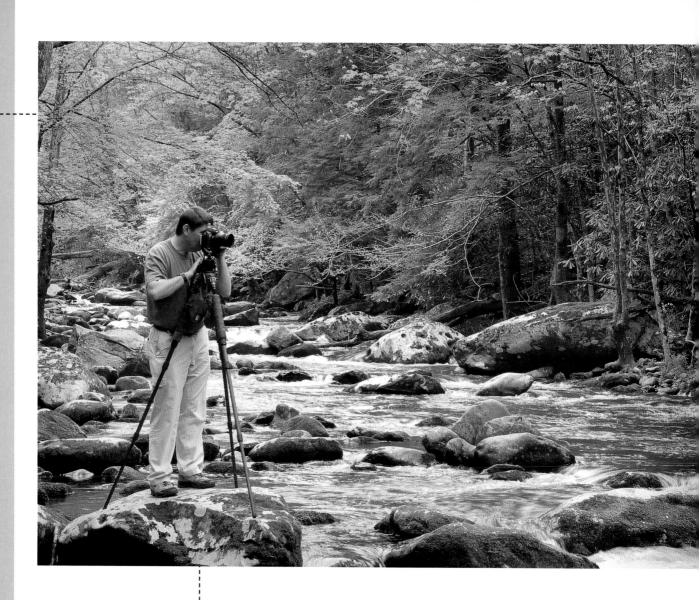

Introduction

Prints are a wonderful part of photography. They give us something tangible for our efforts, something to share, whether hung on a wall or just passed around a group of friends and relatives. They feature our passions about the world and let us express our creative urges. With prints, we can show off our kids, remember important events, relive our trips, and so much more. In addition, prints encourage you and the viewer to talk about specifics in the photo, point to details, and share experiences.

During the height of the dot.com era a few years ago, some "pundits" predicted the end of traditional photography and prints, because it would all be Internet based. That has obviously proved to be non-sense. We all love prints and everything they do for us, from the photo in the album to the framed image on the wall. We even print photos from the Internet!

I find the digital age and photography a superb combination. My goal in this book is to help you enjoy the fruits of this combination, by helping you make better prints. I have to warn you, though, that I am very excited and enthusiastic about this possibility and I am going to try to make some of that enthusiasm rub off on you!

I genuinely believe that making beautiful pictures is fun and exiting. Sometimes people see my photos and tell me they wished they could get such "good prints." You can do it, too! This book will show you how.

To be fair, I really have to put in a warning: making great prints can be hazardous to your sleep. I hear this again and again. You get going on tweaking that little extra bit of detail out of the print, and you get so engrossed that time passes quickly. Past bedtime!

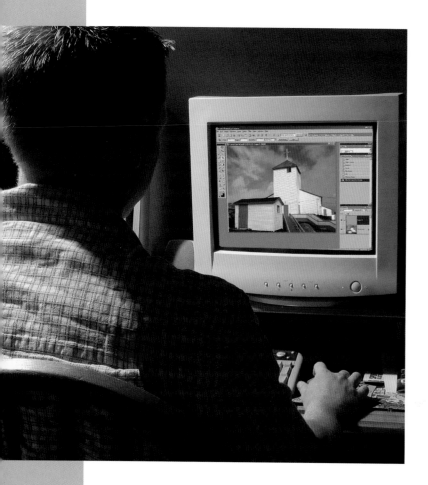

This book is written from the perspective of a photographer. Engineers, computer enthusiasts, and other non-photographers have written a lot of the information that is available about computers and photography. The technology is very important, but an overemphasis on it can obscure the main reason

most of us are working with the computer—better photographs, better prints.

I admit my bias. I don't really care about slavishly following all the technical rules. I do care about photos … and prints. This is a craft, every bit as much as printmakers practice in the darkroom. The digital print has been key in a resurgence of interest in photography. We now have so much more control over our images. While much is done on the computer with Adobe Photoshop and other image-processing software, the print is the most satisfying part of the experience.

In spite of the number of books that are available for photographers working on an image in the computer, very little is out there on making a great print. Sure, there is some discussion of printing, but too often it is limited to talking about color management as if that were all there is to printing. Great prints can be both more and less than strict color management.

Sure, we'll talk a bit about color management. But if this is something you've avoided, because it seems too technical, here's a subversive thought that you'll want to keep in mind: you can get great prints without being overwhelmed by color management.

We'll talk more about all of these things as we go through the book. I'm going to give you lots of ideas —you pick what works best for you in your situation and for your prints. A great print, again, is one that satisfies you, no matter what anyone else says.

Now you might wonder who I am. I have long been a photographer—I made my first darkroom when I was thirteen (now I have kids that age and older!). I worked on my high-school yearbook, then the college newspaper, and started to sell my first photos while still in school. I've worked as a photojournalist, nature photographer, videographer, film and video producer, photography teacher, and how-to writer. I am the second editor of *Outdoor Photographer* magazine, and the first editor (and co-developer) of *PCPhoto* magazine.

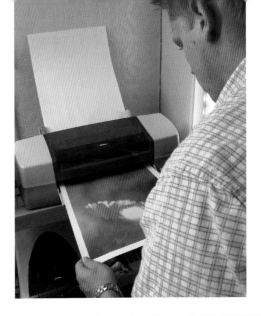

How this Book Can Be Used

This book is a collection of lots of information on making better prints—just like a workshop. You can go through it bit by bit, working out your own procedures based on what is in the book, if that works for you. Read it straight through if you'd like (there is a logical progression in topics) or just keep it as a reference as needed. Skip around to the most interesting parts for you. Or if you want to impress your friends and family that you really have studied ink jet printing, use it to decorate your desk.

Here's an overview of how the book and its chapters are put together so you can best use it to help you with your specific printing needs:

1 **Jumpstart Into Printing—** A quick overview of the key steps and concerns you need to know in order to get started making great photographic prints from your printer.

2 **Selecting a Printer—** What features can be found on a printer? How do they affect performance and price?

3 **Starting with the Right Paper—** The paper you choose is critical to making a great print. Here's how to choose the best paper for your project.

4 **Getting Technical—** Technical issues that affect digital imaging and how images play out as a print are explained, including the always-challenging issue of resolution.

5 **Refining the Image for Printing—**Image-processing Programs—A good image-processing program allows you to make better prints by adjusting the image in many ways. Some tips on selecting the right program are included.

6 **Refining the Image for Printing—** Tonal Adjustments—The brightness and contrast of a photo strongly affect the appearance of the print. Learn the key tools to adjust both.

7 **Refining the Image for Printing—** Color Adjustments—Color used to be considered "unchangeable" in a print, but that's not true today! You'll see how color can be enhanced and adjusted for your printing needs.

8 **Finishing Touches—** Try these to turn a good print into a great print, from sharpening to borders.

9 **Dialing in the Print—** The perennial challenge, how can you make that print look more like what you see on the monitor? What's color management all about and do you really need it?

10 **Displaying the Print—** Photo, photo on the wall, where's the best place to put them all?

11 **Printing Projects—** There are many things you can do with your photos besides making great display prints.

12 **Black-and-White and Panoramic Prints—** Use these tips to make better black-and-white prints from your ink jet and discover the advantages of using a color image for better black-and-whites! And, the big, wide print—how do you shoot for it and print it out?

13 **Making Long-Lived Prints—** Nowadays, you can count on your printer to deliver long-lasting prints, although this wasn't always true. Epson's ink jet printers easily deliver prints that will last as long as a traditional color print, and some of the newest Epson technologies can beat that by far.

14 **Taking Care of Your Printer—**While Epson printers are generally trouble-free, they do need some care. Here are some tips to let you get the most from your printer by taking good care of it.

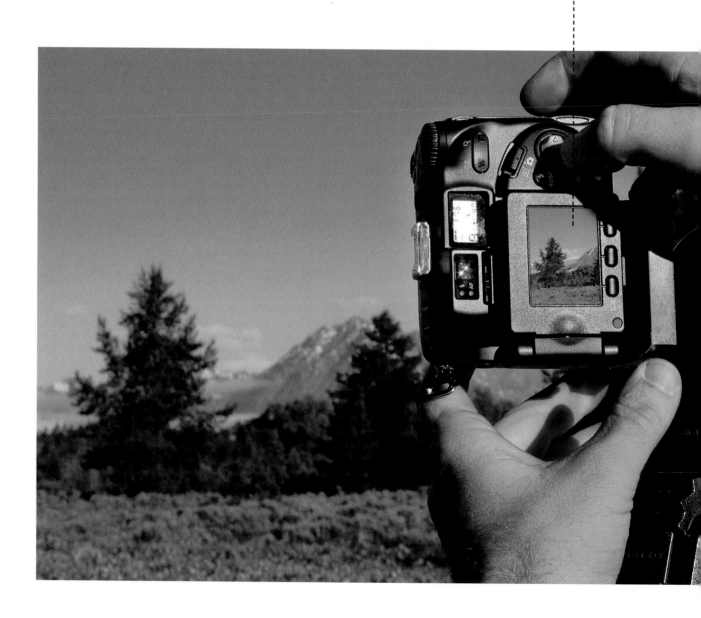

Jumpstart into Printing

Let's get into printing quickly. I want you to have a quick guide to making prints so you can discover the joy and excitement right away. If you follow the steps in this chapter, you'll be able to get pleasing prints immediately. We've got the rest of the book to go into details on printers and refining your print. In addition, this guide will give you an overview of the printing process that you can refer back to at any time as you read the rest of the book.

Finding an Image

You might have thought we'd start with the printer. A printer is obviously very important to the process, but you have to have an image to print first. A challenge faced by too many photographers is finding the photo on the computer's hard drive (or other media). You may have scanned a slide or negative, gotten a CD of images from your processor, or downloaded photos from your digital camera— all great ways to get an image into the computer.

But then you have to find the right photo in order to print it! I know from experience that this can be frustrating. Where did it go? Which folder is it in? And then which picture file is the right one?

You have several excellent options here. I always recommend that people use some sort of image browser program. This software allows you a visual look at the photos on your hard drive, so you actually see images rather than just file names. It makes it so much easier to find photos.

Windows XP has a simple, integrated image browser built into the operating system. When you open a folder, the photos show up as little "thumbnails" (small images). Among a number of options, you can set up a folder to see one photo and a "filmstrip" of smaller images (a few at a time) or all of your images at once as same-size thumbnails. While the photos

aren't big, you can get a good idea of which image you want. You can even print from this point or launch the image directly into a photo program.

Many Epson printers include a more advanced browser and printing program called Film Factory. This easy-to-use software allows you to quickly review images on your hard drive (as well as download them directly from a digital camera) as moderate-sized thumbnails. You can rename photos, set up new folders, group photos into categories (called "Film Cases") and do some simple processing on them fast and easy. The program includes many excellent options for printing, including multiple photos on a page and album pages. This program is available for both Mac and Windows.

A step up in capability can be found in browser programs like ACDSystems ACDSee (Windows and Mac), PhotoDex CompuPic (Windows) and Jasc AfterShot (Windows only). These offer more flexibility in viewing your images directly from a drive and even include some database search functions to help you find photos better. AfterShot and a plug-in for ACDSee called FotoSlate offer multiple ways of making prints, too, with many templates for printing several photos on a page at various sizes.

Finding and organizing your images on your computer hard drive is the first step to successful printing.

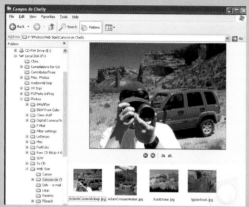

Windows XP includes a simple image browser that shows a thumbnail of each file.

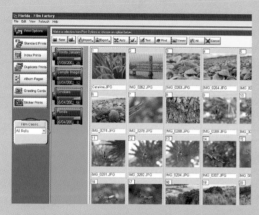

Film Factory, a browser and printer program from Epson, allows you to see and organize images.

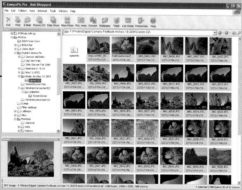

CompuPic is typical of browser programs that allow you to see and organize thumbnails, as well as print an index of images from many files (at right).

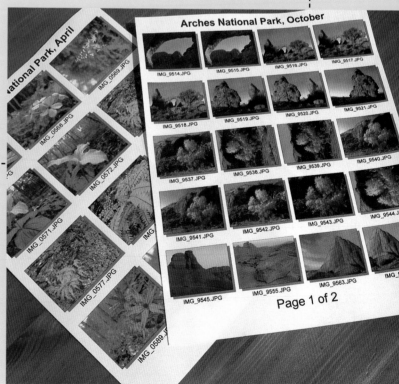

These four browser programs offer one feature that facilitates making prints: index prints. These are also called proof sheets or "contact" prints (named after traditional darkroom techniques—Windows XP also allows a limited contact sheet to be made). These printouts give you multiple choices in how you make a print of all the photo files from a file folder or disk by providing a hardcopy visual index.

I think this is huge! Now you can find the photo you want by quickly skimming through a few printed pages to find the exact image and name. You don't have to open multiple folders on your computer or put a lot of disks in and out of the machine. The index print shows you what you want from your hard drive, a CD, or any other place you have images stored and it is viewable anytime, anywhere. I file my index prints with my CD's—that makes them so much more usable.

You want to make a print of that great sunset over the Pacific, or maybe the shot of the kids at the soccer tournament? Check those index prints, find the file and the location, open it and start printing!

How to Make Stunning Prints from the Start

Of course, to make a great print, you need a capable printer. All Epson printers on the market today make superb photo-quality prints, as good, or even better than what you might get from your local minilab. However, how you use that printer is really critical if you want to get the most from it. Let's look at some of the key steps to making photo prints that you can be proud of:

1 Open the photo file
You can open your photo with a special printing program or image-processing software. Make any adjustments you think you will need to correct and enhance the subject.

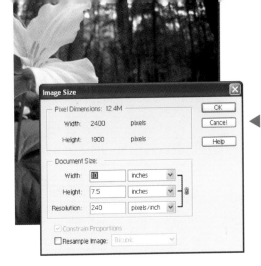

◀ One key element in making a great print is to use the appropriate file size and dpi/ppi.

2 Use the appropriate file size
Your image-processing program will give you a file size. This is so important. Again and again, I have seen good images become poor prints because there was not enough data to support the print size. Without that needed information, print quality will fall off, affecting sharpness, color, tonalities, and more.

The tricky thing, though, is that printers are so good today that they can make almost any print look acceptable in overall color and sharpness, even if there isn't adequate picture data. This can easily fool the viewer into thinking this is the best they can get, when it really isn't. Depending on the printer and paper, expect a 4 x 6 inch photo to print best with a 4-5 MB file (uncompressed TIFF size), a 5 x 7 with a 7-10 MB file, and an 8 x 10 with a 14-20 MB file.

3 Use the right image file dpi/ppi
This one causes all sorts of confusion. The important thing to remember is that the image file will have a dots-per-inch/pixels-per-inch size (dpi/ppi). This is not the same as the printer's dpi. Each refers to different things in the process.

Your image should be at 240-300 dpi/ppi at the dimensions that will be printed, regardless of the printer that is used. This will vary a little depending on the paper that is used, the dpi setting of the printer, and your taste. However, the dpi/ppi number can never stand alone. It is always referenced to the dimensions of the print. Whether the print is 4 x 6 or 8 x 10, the dpi/ppi must be in the 240-300 range for optimum quality.

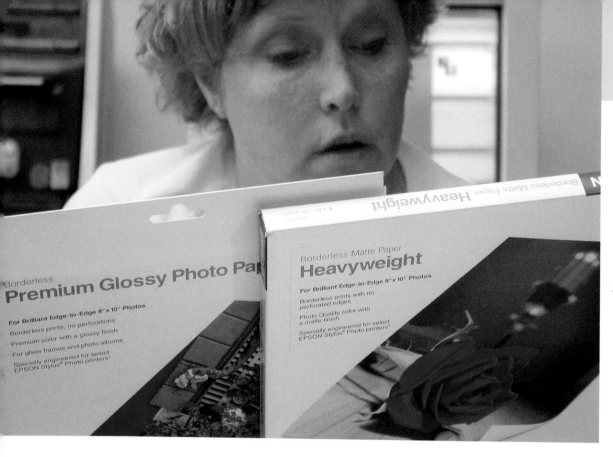

◄ While paper choice is a matter of personal taste, the intended use of the print should also be considered.

4 Choose the right paper

You've probably heard the realtor's mantra of "location, location, and location." Consider "paper, paper, and paper" to be as important in making a good print. This is so important that I expand on paper choices in the next few steps. You are always safe with Epson's papers—you have both quality and creative options with them. You can also test other papers that have unusual surfaces not offered by Epson.

5 Check your paper's weight and usage

The weight of a paper is very important. You need to be sure that it is heavy enough for its intended use. Some of the sharpest, most beautiful prints come from thin, plastic papers. However, these can be uncomfortable to hold and share, if that is important (because they seem very flimsy even though they are quite sturdy). The weight of a photo has less effect when the image is framed and put on display. But if you need a brochure to circulate, you had better be sure the paper is heavy enough to withstand it.

6 Confirm your paper's whiteness value

A white paper gives you pure colors and brighter overall tones in the print. Most papers have a whiteness rating, so check this value (in the 90s is good). Whiteness may not be as critical with some specialty papers (such as certain watercolor papers used for photo printing), because their special tonality is part of the desired effect.

7 Selecting the paper surface

For the best color, sharpness, and tonal range, use a glossy paper. However, this is not a surface that everyone likes. Gloss means shine, and shiny surfaces can be too reflective of bright things around you, making the image harder to see. Matte papers do offer excellent color, sharpness, and tonal range, and many photographers prefer their look. Luster surfaces are in-between. Try making some tests in your own computer system to find your preference.

You can also choose among many specialty papers, including canvas, silk, transparency, watercolor, and more for specific and unique printing effects.

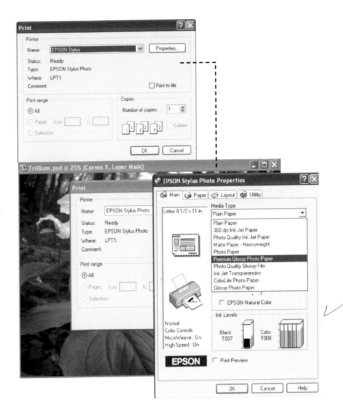

8 Setting the printer driver

I have been surprised more than once by advanced photographers and even pros that don't know that there is a printer driver. This is a dedicated software program that controls how the printer works with an image. The driver's default settings, however, are rarely optimum for photos.

The printer driver is loaded when you tell your computer to print. You'll get a dialogue box that will likely be very simple. To access advanced driver controls, you have to select Properties in the printer dialogue box. In Mac, many driver settings will come up with the print dialogue box. Most drivers will ask you for a paper choice, a quality/speed mode, orientation, and color adjustments.

Usually when you choose a paper, the driver automatically chooses the best print quality/speed for it. Orientation will be Portrait (vertical) or Landscape (horizontal). If you have color management controls (such as ICM), try them at this point. Other settings like Epson's PhotoEnhance can be quite useful (it automatically makes some adjustments to the photo to enhance details and color).

▲ **The printer driver tells the printer how to make the best print on a particular paper.**

9 Making a test

For anyone who has worked in a darkroom, testing is second nature. We always used to make a test print, then check it for exposure, dodging, and burning, and so on. Unfortunately, the hype of numerous people in the computer industry has convinced many photographers that the key to a good print is ... more equipment! Better prints are just a short step away, and you don't always need more equipment.

I've often said that printing really is a craft, in part because it is so subjective. A good print for one person may not please someone else. The craft of printing is mastered by making a lot of prints, testing different papers, settings, etc., then using those tests to refine the image.

In addition, no matter how good your monitor is and how well it is matched to your printing, a print is not the same as a monitor-based image. It is best to evaluate your photos as prints—do they meet your needs or not? They do not need to fit someone else's arbitrary standards that may have nothing to do with your situation—they should meet your specific needs.

10 Recording Adjustments

After you make a test, you should have a better idea of what adjustments are needed for a typical good print (brighter or darker settings than what looks good on the screen, different color adjustments, and so on). Write those down! As long as you use the same printer and paper, these basic adjustments should not change. With most Epson printers, you can also save these settings with the printer driver—we'll explain that later.

Selecting a Printer

Ink jet printers have come a long way from the first models. They were slow, of poor quality, black-and-white only, and could produce nothing that looked like a photograph. Today, ink jet printers offer color, superb text, and photo-quality.

If you are in the market for an ink jet, whether it is a new purchase or an upgrade, you will find a great range of printers on the market. There are definitely differences, so let's look at the ink jet printer to give you a better idea of what makes them different. Then you can decide what makes a difference to you.

How Ink Jet Printers Create Quality Photo Prints

With an ink jet printer, ink is sprayed in tiny droplets onto the paper in a distinct pattern to make all the tones and colors you expect in a photograph. Some folks have given this a French name, giclee (shee-CLAY) printing (which just means sprayed ink prints) to make it seem like some exotic, European technology (so they can charge more for the prints, I think).

Epson printers lay down the ink with a patented piezo-electric printing head. There are variants of this head depending on the level of printer, the number of inks, etc., but basically, this head translates the electrical impulses that represent your photo into drops of ink that are rapidly placed onto your paper to create a beautiful photograph.

Micro piezo technology results in very consistent and precise ink droplets, allowing the printer head to place them extremely accurately, yet at high speed. The printing head actually changes position as it puts these droplets down, running back and forth across the paper as the printer moves the paper in small steps under it. And still with extraordinary precision!

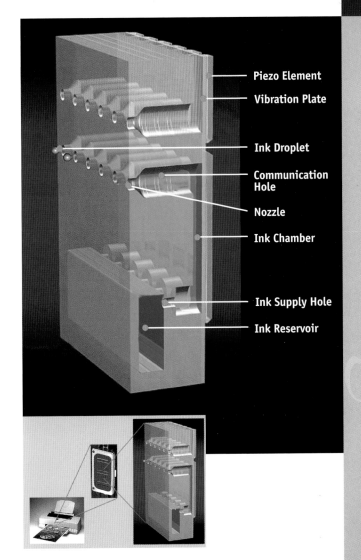

Piezo Element
Vibration Plate

Ink Droplet
Communication Hole
Nozzle
Ink Chamber

Ink Supply Hole
Ink Reservoir

▲ **Epson's patented piezo-electric printing head precisely places tiny drops of ink on the paper to form a photo-quality image.**

This builds the photo, row by row, inch by inch.

Thousands of tiny drops of ink get put down very quickly when you consider they all have to line up exactly right in order to make a photo-quality print. Epson has included a special feature in the printer driver (or software) called AcuPhoto halftoning, which produces accurate color with true photo gradations. In fact, Epson has some amazing, proprietary algorithms (computer instructions in the program) which optimize the image in the print. Top photo quality is highly dependent on a printer's ability to lay down ink in exact patterns and alignments.

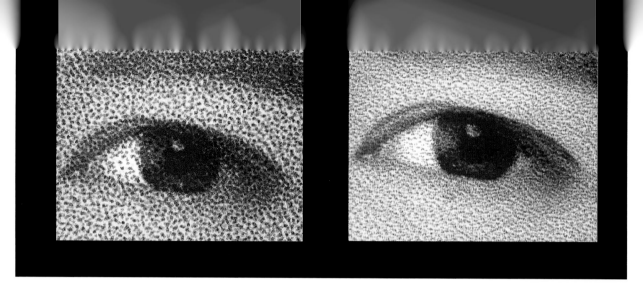

▲ **In the picture on the right, smaller ink droplets (shown greatly magnified so the droplets are visible) give better tonal gradations and color rendition than the coarser droplets on the left.**

In addition, the resolution of the printer (such as 1440 x 720 or 2880 x 1440 dpi) affects how the ink is applied. While higher resolution (up to a point) can produce more detail in shadows and highlights (two of the toughest areas for a printer to deal with), as well as crisper text and fine lines, top photo-quality is not dependent on the highest printer resolution.

Epson printers use ink dots so small that you cannot see them with the naked eye. With smaller droplets, print quality gets better because the printed dots can be blended better and gradations of tone are smoother. This can be more important than resolution.

The droplets themselves come in four distinct colors: cyan, magenta, yellow, and black. All Epson printers have these four colors. The six-color, or photo printers, add pale versions of cyan and magenta to improve color tonalities. This technique is especially noticeable in the highlights and in subtle gradations between tones. The seven-color printers add light gray to the mix for better neutral tones and for increased ability to render subtle tonal gradations. Some manufacturers build black from cyan, magenta, and yellow and reserve the black ink for text, while others make black in a photo from the combination of colors. Epson uses all of the ink colors, including black, in photos to gain better shadow detail, purer blacks, and a denser black that makes the overall photo have more brilliance than even a traditional print from your minilab.

Finally, ink comes out wet, of course, so Epson has engineered a printing process with their ink formulation and printing head so that the ink dries very rapidly. This keeps prints from smearing and makes them water-resistant.

Dyes vs. Pigments

Ink jet printers use two basic types of inks: dyes or pigments. Dyes have traditionally offered brighter colors, but are more likely to fade than pigments. For a long time dyes were the only way to print with an ink jet, since they were the only way to get colored ink through the printing head. It was difficult to develop pigments that didn't clog the head.

Epson was the first to beat both problems. They developed a dye-based ink with improved fade resistance. They also figured out how to make pigmented ink that both flowed easily through the print head and produced bright, saturated colors. Although dyes hold a slight edge for color brilliance and speed of printing, that probably won't last long given Epson engineering ingenuity.

What to Consider When Buying a Printer

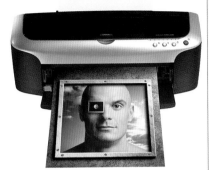

Epson makes a whole range of printers. Since the Epson folks are continuously working to manufacture printers that make better, faster prints, specific models are hard to describe. Here are some key things to consider when comparing models:

1 Number of colors

Lower-priced models have fewer colors, usually four. You will typically spend more for six- or seven-color printers, but you do gain in color rendition, especially in highlights and tonal gradations. While their four-color printers do print wonderful photo-quality images, Epson's dedicated photo printers are optimized for photography with the extra colors that give exceptionally refined results.

2 Droplet size

Smaller droplets can result in better highlights and shadows as well as smoother tonal gradations in a photograph. All Epson printers offer a very small droplet but the more advanced and expensive units typically have the smallest droplets. Droplet size can be more important than resolution in determining ultimate photo quality.

3 Resolution

Resolution is a very tricky issue and can be quite confusing because printer resolution is not the same as image file resolution. It is very important that you keep these things separate. Nearly all Epson printers achieve the excellent 1440 x 720 dpi. That gives a true photo quality to the print. Some offer 2880 x 720 dpi, helpful for detailed line drawings and text on high-quality paper, but this really doesn't affect photos much. Very high resolution does improve the ability of a printer to render detail, as well as enhancing the sharpness of text and line art.

4 Speed

Printers get faster all the time and price generally increases with speed. In looking at the speed of a printer, however, you need to know several things. First, print speed is limited by the computer's processing speed and available RAM—it takes some computing power to process a file for printing and photos are especially greedy. Second, the industry has no absolute standard of speed so you cannot compare brands, just printers within a brand. Third, the industry has some funny conventions about the way speeds are marketed.

Typically, the advertised fast speeds are for draft or economy mode, which you are unlikely to use with photos. No printer can produce a photo at speeds of 10 pages of color per minute. Photos can take minutes and still be fast. Compare fine, best, or photo-quality printing speeds. Epson always includes information on photo-printing speeds with its dedicated photo printers.

5 Noise

Ink jet printers make noise when warming up, printing, and cleaning. More expensive models are usually less noisy.

6 Borderless capabilities

Borderless photo prints have become very popular. People expect them from their print processors. A number of Epson printers offer the capability to print edge-to-edge on the paper. The paper comes out with a full image and no trimming of white borders is necessary.

7 Paper path

If you want to print on very thick papers (up to 1.3mm), check into some of the higher-end Epson printers that include multiple paper paths. You need a straight-through paper path that allows the printer to print on the paper without needing to bend it.

8 Size

Big printers cost more, no question about that. The least expensive printers will handle standard 8 1/2 x 11 paper just fine, but no bigger. The midrange Epson printers (and up) can produce panoramics at 8 1/2 x 44 inches. Larger printers typically handle standard print sizes up to 13 x 19 plus panoramics to 13 x 44 inches. The really big roll printers start at 24 inches wide and go up from there.

▲ **A printer with borderless printing capability will print to the edge of the paper so that no trimming is necessary.**

9 Grouped or individual ink cartridges

Ink typically comes in black plus a color cartridge or in individual packages for each color. Lower-priced printers usually have the grouped color cartridge. Individual cartridges can be more efficient if you do a lot of printing because you can replace each color as you deplete it.

10 Buffer

All printers have some sort of buffer (memory) that allows the data coming from the printer to be stored just before it goes to paper. With lower-priced units, this buffer is typically very small and only of value to the printer. More expensive printers add memory capacity, increasing the size of the buffer, which can affect printing speed to a degree.

11 Accessories

You may have some specific needs, such as printing long panoramics or doing prints on a roll (convenient for printing lots of 4 x 6 inch photos, for example). Check to see if the printer you are considering can use these accessories.

12 Pro-printers vs. consumer types

Pro printers cost quite a bit more than consumer models, yet on the surface, they often seem to have similar features. Underneath the hood, so to speak, they do offer some things that can be very important to professionals who make a lot of prints. Pro-printers are designed for steady, dependable use under the pressure of making nonstop prints, day after day. In addition, their tolerances are so tight that a print done one day looks pretty much identical to the same image printed another day. Some pro models use large ink tanks to make ink usage more efficient for the heavy user.

13 Print life

Epson has been a leader in making printers that produce photographs with a long life. Still, the type of paper used also has a big influence on print life. Epson printers with dye-based inks can output prints with lives of typically 10-25 years, dependent on the conditions in which the print resides. Pigment-based inks have been evaluated to offer print lives a hundred years or more.

14 Connectivity

Previously, printers connected to the computer, through the good old parallel or serial ports. This was fine (and still works), but is not nearly as speedy or convenient as USB. USB connections can be "hot-swapped" or plugged in and out of the computer while the it is on. This provides a fast connection between computer and printer, so that the printer doesn't have to wait for data.

Epson printers also offer networking capabilities. Many of them can be shared over a Macintosh Ethernet network by connecting one of the networked computers directly to an Epson printer via a USB port. When anything is printed from any of the networked computers, the file is automatically sent to the computer that is attached to the printer and printed from there.

In addition, most Epson printers can be connected directly to an Ethernet network by using a print server. Also, Postscript printing is available for a select group of Epson printers. Both of these are fairly specialized uses of the printers for businesses, and are beyond the scope of this book.

15 Direct printing

In recent years, manufacturers have added built-in memory card readers to printers in order to allow printing directly from a digital camera memory card without going through a computer. If you do a lot of casual digital camera shooting and want to make prints quickly after shooting, this type printer may be very useful to you. It has limited adjustment capabilities, however, so for the photo prints that you care most about, you will want to go through the computer anyway.

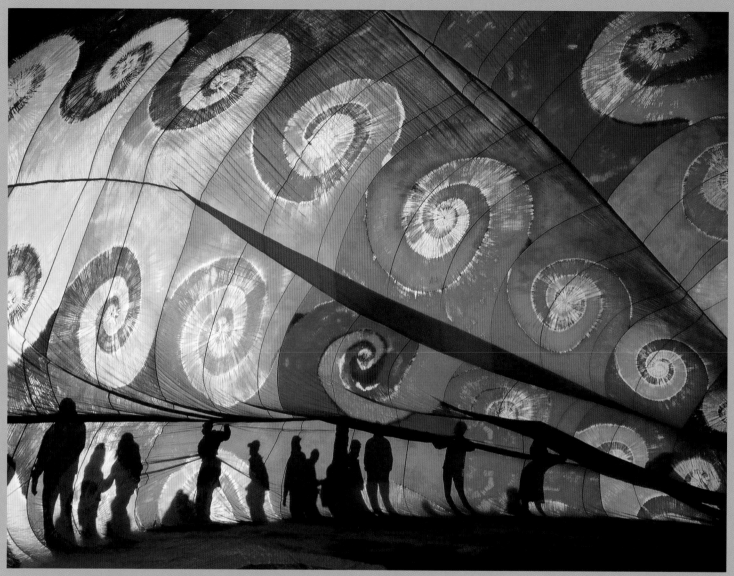

© Bruce Dale

Bruce Dale

National Geographic and Beyond

Bruce Dale has produced over 2,000 published photographs for *National Geographic,* and is also a well-established advertising photographer. He teaches photography and the use of digital technologies, and is a frequent lecturer.

One of the very early adopters of Epson printers for photography, his first printer was actually one of the first models of dot matrix printers that Epson introduced around 1980. He used some of the earliest Stylus Photo printers to begin making color prints from digital files back in the mid-1990s.

Today he uses a smaller Stylus Photo ink jet for traveling and keeps it stowed in his truck. In his office, he has three more Epson printers: a high-volume model that gives him fast and reliable general prints, a larger desktop unit for brilliant and accurate aim prints, and a wide-format printer for gallery prints.

Dale says that the biggest impact of Epson printers on his business is in the final quality of the image. For example, he can make a small proof print that translates identically to a large mural size image. Before, with conventional color printing, he always had to factor in such things as color shifts and reciprocity changes due to printing time. Now, he feels he has total control over the finished product from text to portfolio prints and gallery prints. Furthermore, he always includes aim prints with all digital files sent out for publication, to let the recipients know what the final image should look like. And he incorporates Epson printers in his workshop classes as a teaching tool.

His favorite papers for the desktop printers are Epson's Premium Luster papers, and he uses Epson's Premium Glossy for aim prints. For the big gallery prints, most of his printing is on Epson's Premium Luster paper. For him, choosing the right media is extremely important. He believes Epson has done a great job of fine-tuning their inks and papers to give optimum results.

Dale believes that digital photography and printing have literally surged into serious use much faster than anyone expected. Many printing obstacles and barriers of the past (inferior paper, slow speeds, poor longevity) have fallen by the wayside. But that doesn't mean he isn't looking forward to what's coming next.

Dale's Web site is www.brucedale.com.

Glossy Photo Paper

Glossy Photo Paper

S041465
Borderless Premium Glossy Photo Paper
.256mm (10.4 mil) Thickness
68 lbs/ream (255 g/m²)*
97% Opacity
92% ISO Brightness

Starting with the Right Paper

Ink jet printers have almost improved too much for their own good. They impress marketing types so much that the equipment is often promoted as being capable of superb results on any paper. While it is true that ink jet printers can make prints on cheap paper look halfway decent, they really need quality paper designed for photos in order to produce the best photo prints.

Epson alone makes a wide variety of papers, and there is a growing marketplace of ink jet papers from many suppliers. This large selection of papers can be confusing, but it is also a wonderful thing for photographers, because we can choose exactly the right paper best suited to meet our needs.

There are a number of factors that go into choosing that right paper. In the end, this is a highly personal choice (for example, I may love matte papers, but you think glossy is the only way to go). As you gain experience with the many choices, you will be able to make prints that are a real joy to produce.

However, while lots of papers are "available," you might not be able to find them at a given store.

Check office supply and photo stores as well as the Web. You can buy all Epson papers off the Web if needed. Don't be over influenced by well-meaning but uninformed sales people at retail locations. I have actually had the experience of someone at an office supply store telling me a paper had been discontinued—this would have been a big surprise to the manufacturer. They just didn't have the paper and didn't really understand the paper market.

Paper Weight and Thickness

Every paper has a weight and a thickness. These are both "technical" terms of sorts and a subjective impression you have of a paper. They affect how a paper can be used as well as an impression you get while viewing the photograph—really! A paper's weight and thickness have a psychological impact, which we'll cover in a minute.

All papers can be given a specific weight in pounds (per ream, based on an industry convention for paper dimensions). Thicker papers will usually weigh more, so the weight will give you an idea of how a paper will feel. You may run across a few papers that are full of air, so they can be lighter although still thick. In this case, you have to look at the paper's thickness rating. Paper is also often described in weight terminology, such as a heavy-weight paper.

▶ **Paper weight is important in determining the best choice for a project. In general, heavier papers also convey an impression of quality.**

S041467
Borderless Matte Paper-Heavyweight
.23mm (9 mil) Thickness
44 lbs/ream (167 g/m²)*
94% Opacity
97% ISO Brightness

▲ The surface of photo-quality paper can range from glossy to matte. This is a subjective choice that affects the appearance of the finished print.

The bottom line for the photographer is what do you expect from your print? You need a heavier weight paper if the print will be handled a lot, such as passing around friends and family. Brochures or flyers, too, need some weight or they'll leave a poor impression with recipients. If the print is going to be mounted behind glass, weight is less important.

But here is where that psychology comes in. One of the highest quality papers available is actually a tough plastic material—very glossy, offering high color saturation and sharpness. But it does not "feel" like a photo, so some photographers will only use it for prints that will be framed. The heavier and thicker papers "feel" more like a traditional print.

Opacity

Opacity might be better understood if you think of it in terms of transparency. How easily can you see through the paper? If not very well, the paper has a high opacity. If you can easily see through the paper, it has a low opacity. The thickness and weight of a paper have a strong effect on its opacity. It is measured in a percentage with 0% being fully transparent (no opacity) and 100% fully opaque.

This becomes important when you need to put papers together (as in a booklet) or if you need to print on both sides (such as a brochure). With low opacity, you can see words or photos coming through. High opacity makes the photo stand out on the page, regardless of what is below it. Look for high opacity papers when you do business printing, such as brochures and newsletters.

Surface

The surface of ink jet paper is coated to make the ink look better when laid down as a photo. This surface can vary from very glossy (shiny) to matte (non-reflective), with variations in between.

If you want to really stir things up among photographers, ask which is better, glossy or matte. Some will swear by one, while others will swear at it. This is an extremely subjective matter. A glossy surface will give the photo the highest sharpness, the most tones and the brightest colors. A matte finish can be easier to look at because it is not reflective, and will have its own unique "patina" (surface aura) and color rendition.

There is no right or wrong decision, just choices and you will have to make one. Go with your instincts as to what you like best. Some people naturally gravitate to the sheen of glossy papers, while others truly enjoy the gentler tones of matte. Glossy papers do not fold well (if they fold at all, they often crack and frequently don't hold the crease). You can get glossy greeting card paper with scored fold lines for making your own cards. If folding is required, for example, for brochures—use matte paper.

Whiteness

Papers do get rated for whiteness (or ISO brightness).
Higher numbers mean whiter papers. Typically, you
want as white a paper as possible (rated in the 90s or
higher) because that means your colors will be their
brightest and the tonalities their richest. However,
when using specialty products such as watercolor
paper, where a warm tone is part of the appeal, a
reduced whiteness value may be desirable.

Life

All paper ages. It may yellow and deteriorate from
exposure to light and certain gases in the air
(including pollution). Cheap paper may have acids
in it that can degrade the paper itself (and therefore
the image) after a few years. Better papers vary from
acid-free to plastic coated to minimize this problem.

The inks that are used also limit a photo's life.
Dye-based inks do not last as long as pigments.
However, any ink will last longer with the right
paper. Epson's ColorLife paper, for example, is spec-
ifically designed to work with the ink to increase
its life. For archival pigments, there are matching
archival papers that make a very long-lasting
combination. While you can mix papers designed for
dye-based and pigment based inks with the other ink
type for effect, this is really not a good idea, as the
dye-based inks really do interact differently with
paper than pigments.

Use

How you plan to use your prints will have an effect on paper choice. Will people hand your photos around? If so, look for a heavyweight paper. Do you plan on making brochures or greeting cards? Be sure your paper will fold. Do you want the absolute brightest colors and sharpest images? Then, use a high gloss, very white paper. Do you need to print a newsletter on both sides? Be sure the paper is coated on both sides to optimize the printing. Do you want to sell photo prints? Look for a paper that will impress your buyers in terms of feel and color, but also consider its life.

Specialty Papers

Specialty papers and printing media may offer specific solutions to your photo needs that regular papers can't provide. These range from expensive watercolor papers to special transfer papers that let you make an image that can be ironed onto a T-shirt. You can get transparency film that lets you print on clear plastic that can be backlit or put on a window for a glowing photo image effect.

In addition, there are all sorts of striking and unusual papers that can enhance your photos. These aren't always generally available because of their specialized nature, but a little checking at photo stores and on the Web can help. You can find metallic glossy papers, canvas, silk, all kinds of watercolor papers, and much, much more.

Rolls and Sheets

Rolls and large sheets of paper are important for printers that can handle them. A number of Epson printers offer roll-paper handling capabilities, which make it easy to print multiple prints without having to deal with single sheets of paper, as well as create long panoramic images. A number of Epson printers even include an automatic print cutter that will allow you to leave your printer unattended while it prints and cuts your photos.

With borderless printing and paper rolls, it is quite easy to produce multiple 4 x 6 prints like those you get at the mini-lab, except that the printing is under your control. The printer pulls the roll paper in as needed and you get a long strip of borderless prints that are easy to cut to final size (or are automatically cut with the right printer).

Rolls are really a necessity with panoramic image printing. "Pans," as people often call them, can vary considerably in their depth (top-to-bottom) compared to their width. Epson Stylus Photo printers can continuously print an image as deep as the printer's paper path is wide and 44 inches long.

You can also buy sheets of paper in big sizes for the larger ink jet printers, as well as for panoramics. These sheets are specific lengths cut to fit the width of the printer, for people not using roll holders. In addition, you can find sheets with unique tone and texture.

▲ **Some printers accept roll paper, which can be used for continuous printing of everything from 4 x 6 inch prints to panoramics.**

One-Manufacturer Convenience

Epson makes a diverse line of papers. This makes it very convenient and consistent for you because the printer driver (the software that controls the printer) includes settings directly linked to specific Epson papers.

There are some fine papers being made by a variety of sources, including some paper types that you can't get from Epson. Still, as much as possible, you will find it helpful to use Epson printing papers.

Epson printers and their drivers are definitely optimized for these papers, which should come as no surprise since the company has a lot invested in printer quality and wants buyers to get the best from the combination of printer, ink, and paper. You will also find that some independent papers that supposedly work well with all printers do not. This may result in weird effects as the ink pools in dark areas, for example.

In addition, Epson has created paper profiles for its paper products. We'll get into the technology of color management later for those readers interested in it. Briefly, you can set up color profiles for scanners, monitors, printers and paper so that your prints will look more like you expect. Epson even gives you profiles for its paper that can be "plugged in" to a color management workflow.

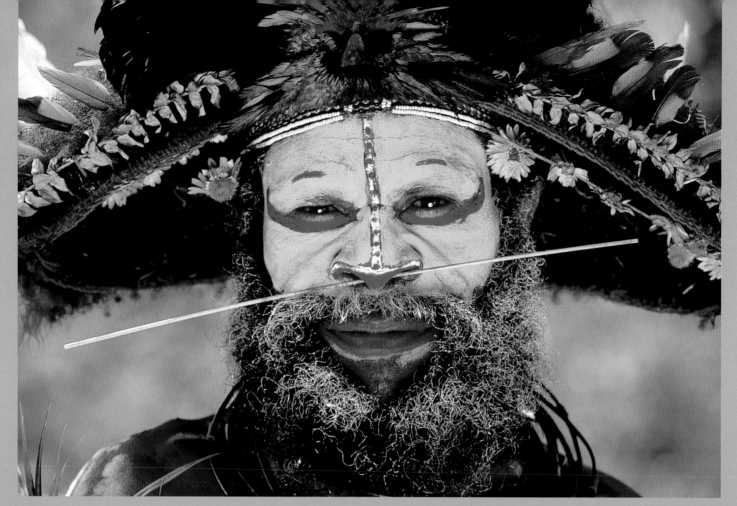

© Bob Krist

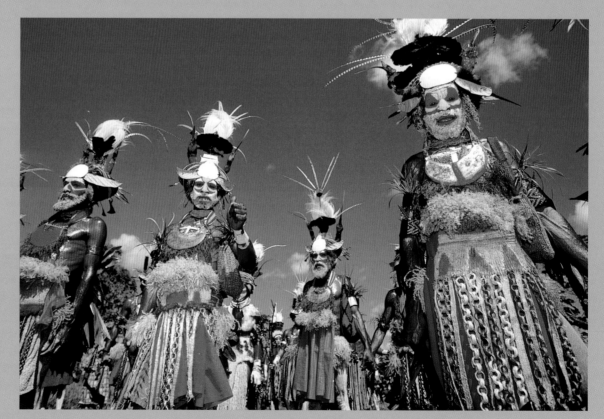

© Bob Krist

Photographer

Bob Krist

Travel Photography

One of the world's best-known travel photographers, **Bob Krist** shoots for a variety of travel magazines, such as *National Geographic Traveler, Smithsonian,* and *Islands.* He is also a contributing editor at both *National Geographic Traveler* and *Popular Photography* magazines.

He's been working with Epson printers since the late 1990s, and continues to use them for portfolio work, magazine submissions, gallery exhibits, and print sales. Krist uses a variety of papers, but tends to favor the matte finishes such as Epson's Enhanced Matte and a variety of fine art papers. For standard portfolio-type prints, he uses Epson's Premium Semi-Gloss paper. Overall, he's excited about the level of control the Epson products have given him.

For Krist, Epson ink jet printers have also opened up whole new areas for his business. For example, now he can sell his own art prints, which has given him a new income stream beyond being strictly an editorial photographer. In his mind, the quality/expense ratio is very, very good, since the Epson prints look as good as transparencies, and offer the chance to give a better presentation of his work.

When he's using the printers for proofing, Krist trusts the Epson printer to do its job well with just a little tweaking. Once he gets the prints to look like a transparency, he's happy—and proud. As he says, "If I want a picture up on my wall, 'bam'—there it goes. I don't have to sit in the dark and breathe bad fumes."

Web site: www.bobkrist.com

© Bob Krist

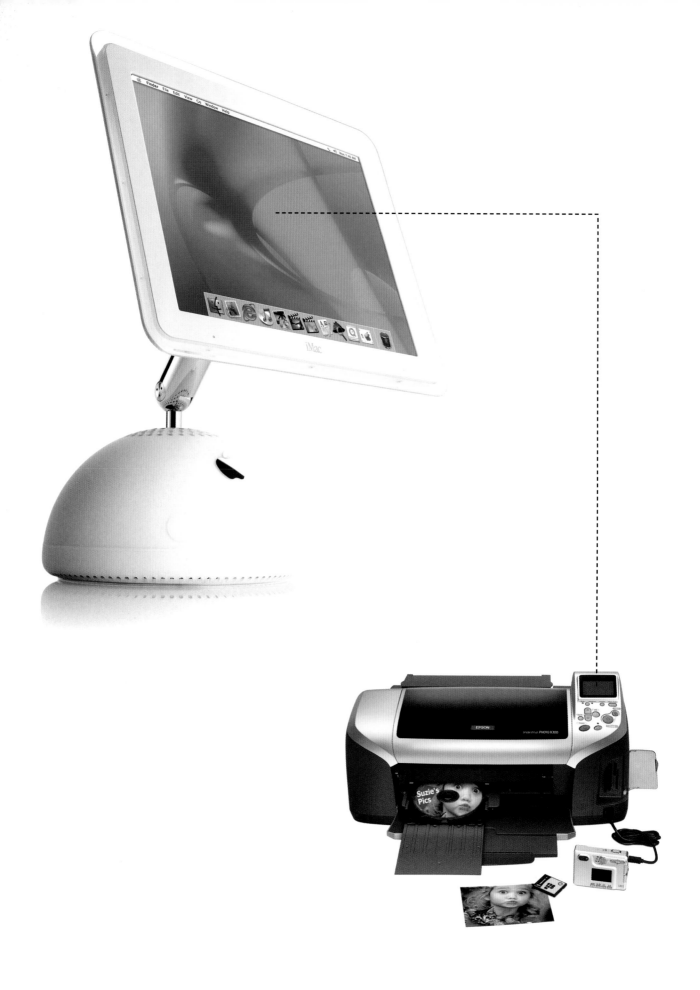

EPSON COMPLETE GUIDE TO DIGITAL PRINTING

Technical Interlude

Can you skip the technical stuff and still get great prints? Actually, you can. However, photography has always been a mixture of technology and art. Getting the most from your printer does require you to understand some key technical details. This will not be an engineering discussion, though. I will try to bring the technical information back to relate to your primary purpose—making a print that truly satisfies you.

Mac vs. Windows

Okay, let's get this out of the way. Printers basically don't care where the data comes from. Photographic prints from an Epson printer look the same whether they start inside a Mac or Windows machine. In spite of the passionate arguments on both sides, for our purposes, there is no arbitrary better or worse to these excellent platforms. Both crash at times (although the most recent versions of operating systems in both do control this better), both can be either wonderful or a pain to deal with, and this can change in a matter of minutes.

The best computer platform for your printer really comes down to several things:

1 What platform do you use now and are you satisfied with it? If you are, there is no reason to change.

2 What do you use at work? You can either choose to continue to use something you are in constant contact with, or you can decide you might want something different, because it will be a break from work. It is not very hard to go back and forth between platforms after a short time of experience with either.

3 What do your friends use? It is best to use a computer platform of the same type as your immediate circle of friends and family. This way, you are more likely to get help and support when things don't work as they should (and sooner or later, this happens with any computer).

4 What are your software needs? If you have specific software needs that are only satisfied by one platform, then your choice is limited.

5 What style is aesthetically pleasing to you? There is a big range of computer designs in monitor and "box" (the CPU and computer guts).

◀ **Whether Mac or Windows platforms are used will not affect the appearance of the print, however, the printer interface is different for each.**

In this book, we don't specifically deal with either platform because it isn't necessary. There is nothing about ink jet printing that is unique to either Windows or Mac. Now, if you were a graphic designer, you might find some advantages to the Mac. Almost all commercial printing companies are set up to use the Mac; much fewer have any kind of Windows system. In many business settings, the Windows system has advantages because it has more software options.

The Printer Driver or Software

This unassuming part of printing, a partly automatic bit of software, is often taken for granted. Yet, it is a key part of the printing process. The wrong driver settings can totally change the look of your print. It can look like you spent some time readjusting it in your image-processing software, even though you never did.

The printer driver is the printing control part of your printer's software. Other elements of that software include such things as a utility to check ink levels, print head cleaning, alignment, and so forth. The printer driver comes up as soon as you tell the computer to print whatever is on your screen.

Once the printer driver comes up, you will find you need to make some simple, but extremely important, choices as to settings. The printer will automatically give you the right settings for a given paper, but you have to tell it what kind of paper you are printing on. Epson has worked very hard to develop complex algorithms (or computing instructions) to optimize your image when printed. These do their work quite well, but do require some simple choices in the printer driver.

Let's go through the key parts of the driver, as you would set it for printing. First, we'll do Windows then Mac, as they have different looking dialogue boxes, though the final choices are the same:

For Windows Users

1 Open the driver by going to the print part of your program's menu, to a printer icon, or if you use the keys, by using Ctrl P.

2 Be sure the correct printer is selected if you have more than one attached.

3 Click on Properties (**A**). In some software, there may be an additional window or dialogue box that comes up with a button that says Setup, Printer, or Options. You may need to click on those to tell the software how to deal with the photo it sends to the printer. The look of the driver interfaces can change, but their functionality remains essentially the same.

4 You should see the Properties dialogue box, labeled as such at the top.

▲ **A. Click on Properties in this Windows print dialogue box to get to the Epson printer driver.**

▲ **B. Choose the paper type to match the paper in the printer.**

▲ **C. PhotoEnhance settings are worth trying with digital camera files.**

▲ **D. The Paper section tells the printer how to deal with the paper in use.**

▲ **E. The Layout section accesses special features.**

5 The Main section (**B**) asks you to choose the paper (Media Type), ink color, mode, and print preview. Choose a paper type that matches the paper in your printer. For all photographic printing, you will choose "color" for the ink color (even for black-and-white prints). For much of your printing, you will find that Epson has done such a good job optimizing its software that leaving the mode on automatic works great.

6 PhotoEnhance: You can also choose Photo-Enhance (**C**). This is a good setting to try with digital camera files that have had minimal modification because this setting will make some adjustments to the file to brighten and intensify the image. You can certainly try it on any photo, though. You will have some choices in this setting based on the type of photo and a couple of special effects. Again, Epson has done a lot of work to make this PhotoEnhance setting give you better prints. You probably won't use this mode if you are doing any significant corrections to the photo, but it only costs a sheet of paper to try if you aren't sure. This setting doesn't change the image file in the computer. Custom is an advanced setting that we will cover later.

7 The Speed/Quality slider in the mode area should be on Quality for photos. It is automatically on Speed for plain paper and can be set to speed if you want a quick print to check placement of a photo on a page, for example. It will print faster, but not at top quality, so it should

never be used to judge what a print would look like when it is printed at top quality.

8 Use the Print Preview by checking the box if you want to see the placement of the photo as it will appear on the page.

9 The Paper section (**D**) gives some additional information to the printer. Here you let it know where the paper comes from (e.g., the standard sheet feeder or a roll feeder), the size of the paper (which is very important when you use anything other than the standard 8 ½ x 11), the image orientation (the printer needs to know if it is Portrait or Landscape) and how to use the area of the paper, Printable Area.

10 The Layout section (**E**) is a special area that accesses features for advanced users. It will let you adjust a photo to better use the page. If you have a file capable of printing larger than the paper, you can tell it to "Fit to Page" and the printer software will accommodate you.

You can also do some special printing, such as putting several pages on one (N-up)or making a poster bigger than the printer's size by using multiple pages. You can even add a special "Watermark" to clearly identify the photo as yours.

11 Click "Ok" to accept the settings, then click "Ok" on the first Print dialogue box.

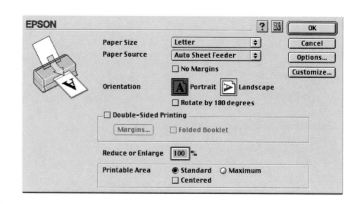

▲ A. The Epson printer driver is accessible through the Page Settings choice in the program's file menu for a Mac.

For a Mac, the process is similar so read through the Windows section for some notes about settings that do apply to both platforms.

For Macintosh Users

1 Open the Page Setup option on the menu (**A**).

2 Be sure the correct printer is selected if you have more than one in use.

3 The Page Setup box is like the Paper section of the Windows driver. Here you tell the printer the size of the paper (which is very important when you use anything other than the standard 8 ½ x 11), where the paper comes from (e.g., the standard sheet feeder or a roll feeder), the image orientation (the printer needs to know if it is Portrait or Landscape) and how to use the area of the paper (Reduce/Enlarge and Printable Area).

4 Open the main printer driver (**B**) (you can just go to Print in the File menu). Now you need to choose the paper (Media Type), ink color, and mode. Choose a paper type that matches the paper in your printer (**C**). For all photographic printing, you will choose "color" for the ink color (even for black-and-white prints). For much of your printing, you may find that leaving the mode on automatic works great. You can also choose PhotoEnhance. See the section in Windows for more on this. Custom is an advanced setting that we will cover shortly.

5 The Speed/Quality slider in the mode area should be on Quality for photos. It is automatically on Speed for plain paper and can be set to speed if you want a quick print to check placement of a photo on a page, for example. It will print faster, but not at top quality, so should not be used to judge what a print would look like when it is printed at top quality.

6 Click "Print" to accept the settings and start printing.

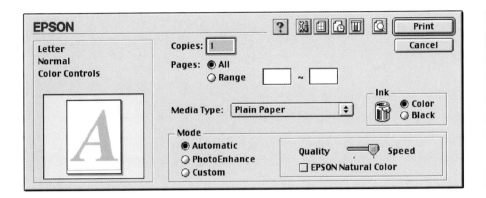

B. Be sure the paper, ink color, and mode are chosen appropriately.

C. Paper choices are critical to ensure the printer lays down ink properly.

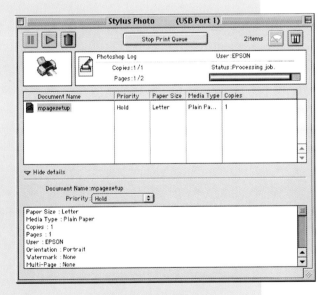

The printer dialog box keeps you informed on the status of printing by displaying a list of documents being sent, or waiting to be sent, to the printer.

!

Working with your Epson printer driver is easy!

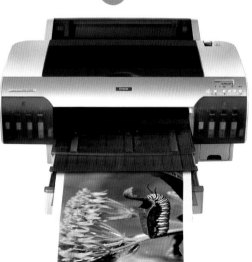

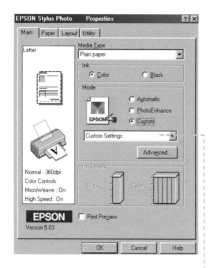

The Custom mode provides more choices for your prints.

Custom mode includes several options for color management.

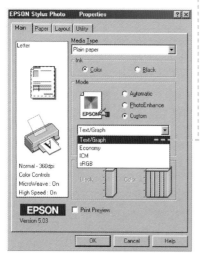

Advanced settings allow you to choose many of the printing settings that the Epson driver would otherwise set automatically.

You can even increase color rendition options by choosing among Vivid, Photorealistic, or Automatic.

Custom or Advanced Settings

Epson has added a Custom settings button to its printer drivers in order to let you make more adjustments so your prints come out the way you want them. You'll find the start of this process in the Mode section of your printer driver. Select Custom and you'll see new choices. However, you may never need to access this part of the driver if you are getting what you want from your photos with the standard settings.

First, note one part of custom settings includes choices for ICM (Image Color Matching for Windows), RGB (standard Red Green Blue—Windows only) and ColorSync (Macintosh control). These are color management profiles that tie your printer closer to particular applications in the computer. At this point, you can try them and see if they help, but we'll get more into color management later.

The Advanced Settings choice can be very useful. It opens up a whole new set of possibilities for your printer. You can customize your settings such as Print Quality, Saturation, Color Balance, and Gamma and even save these settings. For most printing you can let the driver software choose this for you based on the paper type.

However, the Advanced Settings do let you control color in several ways. You can adjust the color saturation with the Mode choice (Automatic, Photo-realistic, Vivid).The only way to see what they can do for you is to try them. Color adjustment can be very helpful in tweaking a print to make it look more like what you see on the monitor. We will cover this more in detail later in the book.

Gamma basically refers to the contrast of your printed image (not the image as displayed on the screen). Most of the time, you'll find the default setting, 1.8, works fine. You can try 1.5 to reduce the contrast of your print or 2.2 to increase it.

If you find that certain choices in Advanced Settings help with specific projects, like printing a brochure with multiple photos on a special paper, you can save these settings as a group. This allows you to go immediately to the same settings the next time you do the same type of printing.

Resolution

One issue that consistently comes to the attention of the editors of PCPhoto magazine is resolution. It is one of those subjects that causes headaches in the digital darkroom. Since something related to resolution affects every step from image capture (scanned or digital camera) through work in the computer to the actual print, we have to understand it to get the most from our prints.

In traditional photography, resolution is consistent. A lens, for example, could have its resolution checked and that resolution would not change. It would be nice if resolution worked the same through the whole digital process but unfortunately, it doesn't and this is where the confusion starts.

If you remember nothing else about resolution, always remember this: Image resolution and printer resolution are not the same. Photographers get into all sorts of trouble when they forget this. One of the most common printing problems is printing at the wrong image resolution. This shows up on the print as less sharpness, poor gradations of tone and color, less contrast, and weaker color.

▲ The images above demonstrate the visual differences dependent upon the resolution. The large image (top left) is at 300dpi. The cropped image at top is printed at 150dpi, while the image just above is printed at 72dpi.

The resolution of your image has a direct effect on the sharpness and quality of the print. Always remember that image resolution and printer resolution are not the same.

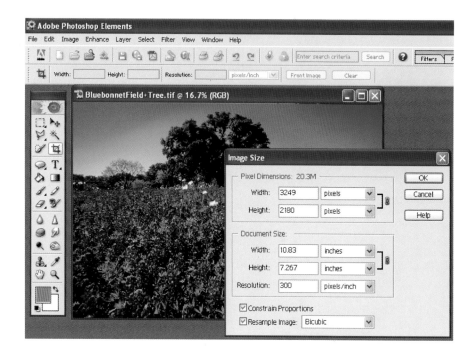

◀ **For the best print quality, set the resolution of your image to 200-300 dpi.**

Image Resolution

In order to get the best prints possible from your ink jet printer, you must start with the appropriate image resolution. Sure, the type of scanner or the brand of digital camera you use will have an affect on the resolution of the image file, but this is a secondary part of the equation and mainly affects how big you can make a print from a given file.

I'm going to give you one number to remember: 300. This is a conservative resolution that will always give you the best quality from your Epson printer, regardless of the printer resolution. Purists like to use the ppi (pixels per inch) term for this resolution, but most people interchange it and dpi (dots per inch). They really refer to the same thing, so 300 dpi is a good image resolution to start with.

Since this is a conservative, safe number, you can often go less (200-300 dpi works well with most Epson printers, and lower numbers often work fine with absorptive papers like watercolor paper). Again, do a little experimenting here to see what is acceptable for your situation. Going much higher than 300 dpi does you little good and can actually cause problems, including computer crashes.

Dots per inch/pixels per inch refer to how many pixels are crammed into an inch of a photo. Spread the dots out and you get a lower dpi/ppi. Push them together and you get a higher dpi/ppi. Spreading pixels out or mashing them closer has no effect on the image quality of the photo file, it only tells the computer to look differently at the pixels that make up the file.

I know that printer marketers have hammered home other numbers associated with ink jet printers and some are making wild claims today. So 300 dpi may seem to be way off. After all, Epson printers print at 1440, 2880, and even 5760 dpi. That's quite a bit different from 300 dpi. So what's the deal?

Image resolution refers to actual pixels in a photograph. Printer resolution refers to the way the printer puts ink down on the paper. The printer will print the image at 1440 dpi regardless of the image resolution.

Printers actually decline in print quality if the file resolution is too high. The not very scientific answer: the software driver doesn't know what to do with the extra pixels beyond 300 ppi/dpi, so it randomly throws them out. Unfortunately, the pixels that were thrown out may be important, so the printer may print an inferior image, even though the resolution of the image is higher.

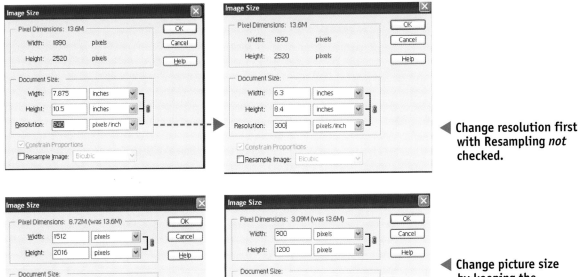

Change resolution first with Resampling *not* checked.

Change picture size by keeping the resolution constant and checking Resample.

Checking Image Resolution

Check your image size and resolution in the Resize part of your software. Image browsers usually give this information as well. You then change the resolution without changing the file size at this point (without resampling) to 300 dpi/ppi. The dimensions will change as you do this, but not the overall file size. When you change only the dpi/ppi without changing anything else (no resampling, so the file size stays the same), all you are doing is telling the computer to look at the image differently by spreading the pixels out or making them closer together. Spreading the pixels out will make the image a bigger size. Bringing them closer together will shrink the image size.

Image resolution always has two components, the ppi/dpi and a size. It is meaningless to know an image's ppi/dpi without knowing its size at that dpi. Another way that an image's resolution is often given that sort of combines this information is as an area resolution. (Although technically, this is not how resolution originally was defined.) The area resolution is a finite amount of pixels, either a total (as in megapixels), or the height and width dimensions in pixels. This does give you an idea of print size potential, although until the dpi of an

image is defined, you cannot specify exact dimensions. We'll look at how you do that shortly.

You can look at an uncompressed file size to see at what size the image can be printed for top quality. A good guideline is this: an uncompressed (TIFF) 4-5 MB file will do a fine 4 x 6 inch print; a 7-10 MB file will easily give a 5 x 7; 13-20 MB will make a great 8 x 10. Again, these are conservative numbers and you may find you can make larger prints with each. Also, the type of image makes a difference— digital camera image files enlarge with better quality than scanned images.

Image Guidelines	
File size	**Print size**
4-5 MB	4 x 6 in
7-10 MB	5 x 7 in
13-20 MB	8 x 10 in

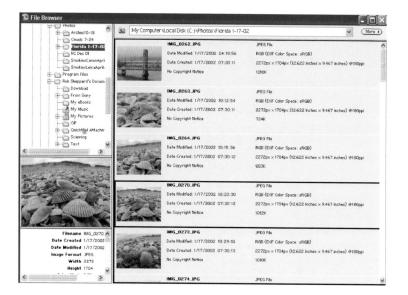

▲ **You can check the resolution, area resolution, and file size of a photo in an image browser, and the area resolution in Windows XP Explorer.**

Resolution and Print Sizes

Once you start understanding resolution, you'll be able to see how much resolution you will need in a scanned photo in order to make a certain size print, or how many megapixels you'll need from a digital camera. You'll also be able to look at a photo's area resolution to tell how big a print can be made. Multiply the dimensions of a print in inches (such as 8 x 10) times 300 (an easy number to use for dpi) and you will get the area resolution needed. For the 8 x 10, this would be 2400 x 3000 total pixels, 2400 on the eight inch side, 3000 on the ten inch side.

So you need an area resolution of 2400 x 3000. If your image has significantly less than this, it will not make a great straight print to 8 x 10. It will need to be magnified through pixel interpolation where the pixels are spread out, and then the gaps between them are filled by the computer's intelligent guesses as to what belongs in between.

You can get there in several ways. You could use a digital camera with a high enough resolution. Technically, this would be about a 7-megapixel camera, but actually smaller digital camera files will print well to this size. Still, they must be enlarged and sharpened in an image-processing program for best results. You'll see this in the resize and resample commands of many programs.

With a film scanner, this means you'd need a minimum of 2400 dpi for a 35mm scan. The narrow side is one inch, so all of the pixels needed for the full eight inches of the 8 x 10 (2400) have to fit into this one inch. With a flatbed, you'd need 600 dpi for a 4 x 6 (you need to get all 2400 pixels on the short side out of four inches or 4 x 600) or 300 dpi for an 8 x 10. In this case, the printing size is the same as the scanned size, so a print at 300 dpi requires 300 dpi for the scan.

You should note that the smaller the original image compared to the printing size, the higher the resolution needed for scanning. The only way to make an image bigger in the computer is to increase pixels, by scanning at a higher resolution, using a higher megapixel camera or having the computer interpolate pixels. The first two are always preferable to the third, because with them the pixels correspond to real things (whether elements of film or a print for a scan or parts of a scene with a digital camera) rather than being made up by the computer (interpolation).

Printer Resolution

Epson printers come with several resolutions: 360, 720, 1440, 2880, and 5760 dpi. Let me repeat this very important concept: printer resolution and image resolution are two different things. If you were to try to make an 8 x 10 print, for example, with an image resolution of 1440 dpi, you'd see a reduction in print quality and a terrible slowdown of your computer at the minimum, and in the worst case, a complete crash of the system. Also remember: printer resolution is not enough to define the highest quality in a print.

You will actually see printer resolution listed as two numbers, such as 1440 x 720 or 2880 x 1440. The first number is very important in looking at resolution, but the second number is critical for highest quality, as it refers to how the ink jet head actually puts these ink droplets down in the second dimension of printing. Since printing makes a two-dimensional print, the second number actually fills in the ink in the second direction.

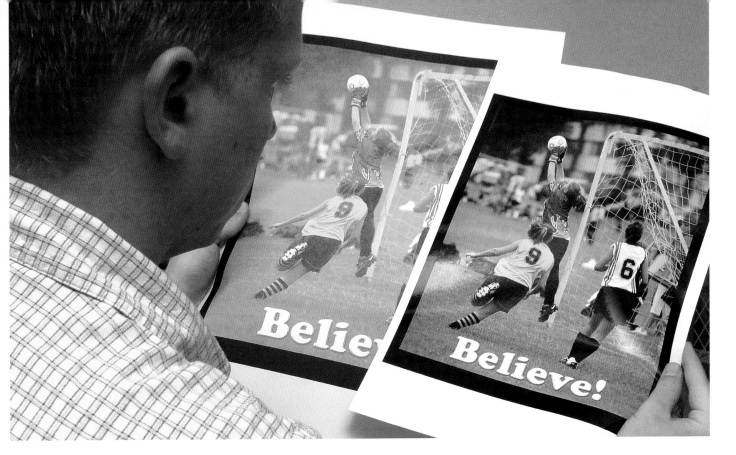

▲ Always be sure you set your printer driver and resolution settings correctly. The difference between using a right or wrong setting can be quite dramatic.

Your Epson printer will automatically set the correct dpi for the paper used as long as you set your printer driver correctly by choosing the appropriate paper setting. If you go to the custom/advanced settings, you'll be able to choose the exact printer dpi you want for a specific purpose. The higher the dpi, the better small details are rendered and tonal changes (the gradations between colors) are improved. For most photo printing, you may find that 1440 gives you results hard to distinguish from higher resolutions. In addition, higher dpi also means slower printing and more ink is used.

360 is fast, but not a photo-quality setting. 720 and up are photo-quality choices. For many purposes, you may find that 720 dpi is a good compromise between quality and speed, especially on matte papers. Try it and see what you like. 1440 gives the very high photographic quality that Epson printers are known for. 2880 and 5760 are slightly better, but the difference may be hard to see on many photos. Where this may show up is in subtle highlights and shadow detail on glossy paper. However, the time required to print at the higher dpi's goes up dramatically and may not be worth the effort on most photos.

Crashes

I mentioned that trying to print at very high image resolutions can cause crashes. This is because the large image files stress the computer's resources. It is almost as if the computer has trouble figuring out where to put all that data: in RAM in a temp file, or on the hard drive? So rather than dealing with that, because a computer is too smart to be bothered with such mundane tasks, it just says forget it and crashes.

Of course, the technical reasons behind this are far more complex. But the point is that big photo files are most likely to cause crashes. This is not un-common when printing, because the computer needs processing power, (RAM and hard drive space) to be able to process a file for printing. If you seem to have consistent crashes when working with photos, try adding more RAM to your system, (moving it up to 256 MB or more). This frequently solves the problem.

© George Lepp

George Lepp

Nature Photographer and Master Teacher

As the Field Editor for *Outdoor Photographer* and *PC Photo* magazines, **George Lepp** is one of the most widely respected nature photography experts in the business. He also directs the Lepp Institute of Digital Imaging, and conducts seminars across the country on outdoor photography and the digital darkroom. His extensive experience in location photography gives Lepp a teaching perspective that few other photographers can match.

He's used Epson products since the introduction of Epson's first photo printer. Today he uses them both for his own high-quality prints and as teaching aids for his students, so they can learn to master the digital darkroom.

Lepp relies on several models of Epson printers, from the smaller desktop units to the wide-format printers. He enjoys experimenting with a range of different papers, but prefers Epson's Luster paper for general printing, and watercolor papers for most of his display prints.

© George Lepp

Epson printers and the computer have given what Lepp calls the "second half of photography" back to photographers. "Before, once the photograph was taken, working on a color image was difficult for the average photographer. Now there's complete control from start to finish." For example, he can now optimize different aspects of his image in the computer—and in the print. "Using the image I captured as a starting point, I can now make it closer to what I saw in the subject, or I can change things around and experiment," Lepp says. "And I can print them immediately to see how they turn out, which is better than sending out a transparency for printing. Prints seldom match the transparency anyway."

For Lepp, new printing technology has become a wonderful tool to ignite a joy and passion for photography in ways never before possible. He embraces the technology as it evolves, and encourages his students to do so as well. For example, he is a fan of Epson's new UltraChrome ink set, since it gives him an incredible color gamut combined with long-lasting print life—opening new possibilities for creative expression.

More on Lepp and his classes and workshops can be found at www.leppphoto.com.

Refining the Image for Printing—Image-Processing Programs

What do you expect from your photographs? A nice likeness? A photo that looks real? A print that you can be proud of? An image that says something special about your subject?

All of these are reasons that we take photos and make prints. And to really get the most out of these images, we now have some wonderful things we can do in the digital darkroom, the computer. You will find that some photos require a lot of work to look their best, yet others may require little or nothing. I don't spend a lot of time on every photo that I print, and I wouldn't expect you to do that either.

Sometimes you just need a quick and easy print for reference or to give a friend or relative. When the original was shot on a digital camera you can simply use an Epson direct printer. Then again, you'll often find that a print can be made much more satisfying with a quick tweak of brightness or color.

I want to give you some ideas on how to work with an image-processing program to create an image that will give you a print that will satisfy you. Now I do recognize that having lots of controls in an image-processing program can make folks want to try everything and not necessarily be happy with any of it. Hopefully, these next few chapters will offer you a little different look at how you might control an image so that you will be able to make the prints you want.

There are many good programs on the market today for adjusting photos. Adobe Photoshop is probably the best known and does offer some superb features. However, it is expensive and has a steep learning curve. Photoshop Elements can do nearly as much for the average photographer, but for less money and time investment. Photoshop is very powerful and worth the investment for those photographers who need it. However, this is not an issue of quality—both are high-quality programs. Photoshop simply offers some specialized tools that are worthless to someone who does not need them, and absolutely essential to those who do.

There are other excellent programs on the market, from Jasc Paint Shop Pro to Ulead PhotoImpact. Nothing in the next two chapters is specific to any one program.

Once you discover the possibilities of what you can do in the digital darkroom, your print options increase, along with the possibility of making really stunning prints that satisfy your deepest creative urges.

Image processing programs typically come as icon/button based (often very easy to use) and menu-based (with a steeper learning curve, but also with more controls).

Adjust the brightness of the highlights and shadows

◀ JASC Paint Shop Pro (left) is a low-priced, menu-based program with a great deal of power.

Adobe Photoshop (below) is a very powerful menu-based program with a steeper learning curve.

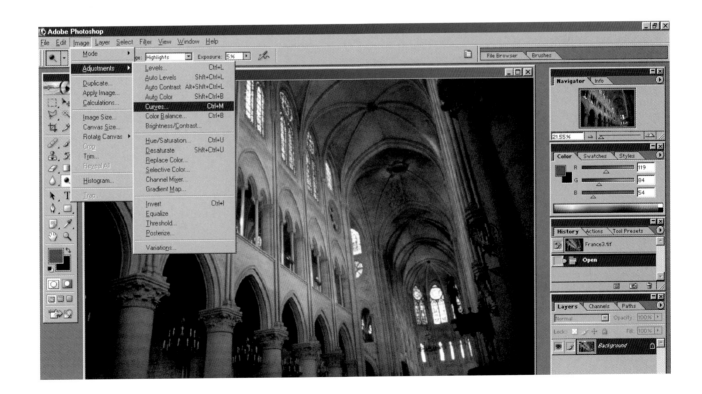

But the Software is Overwhelming!

I'm going to let you in on a secret that I share in my workshops and magazine articles. You don't have to know everything about how a program works in order to use it to make beautiful prints. Unfortunately, a lot of books try to cover it all so that every last detail of a program is unearthed.

No matter what program you use, you are the photographer and your photo is the important thing, not the program. It doesn't matter how many filters a program offers, for example, if you only use two. If your photo looks great after simply adjusting the brightness and contrast, you've done just the right thing!

You're the photographer; you're the one making the prints. Learn, experiment, and work to make your images better, but trust in your judgment. You're the only one who can ultimately decide if a print should be lighter or darker, not other photographers, not computer software engineers, Photoshop gurus with a need for control.

Learn the software in bits. Master each part as you go. But never worry if you don't know it all. Few do.

Image-Processing Software

So what is the best image-processing program? Every year we try to address this in *PCPhoto* magazine's annual buyer's guide. I honestly don't believe there is one best program, appropriate for everyone. A better question might be: "Which is the best program for what I want to do?"

First, never simply pick a program based on how many features it has. If you don't need certain features, ignore them. Look at a program's features in terms of what might be useful to you. This may be hard if you're a beginner. In that case, start simply with an easy-to-use program even if it doesn't have everything possible.

Second, every program has a certain "personality" that comes across in its interface and how it works. You can get an idea of personality based on how the program is promoted on the software box, by checking the manufacturer's Web site and by seeing whether the program is button/icon- or menu-based.

Any program is going to work its best with someone who spends the time to master it and the craft of the digital darkroom. I guarantee that my 14-year-old daughter will do better with Microsoft Picture It!, which she knows well, than a neophyte on Photoshop.

One way of categorizing programs is too look at how most actions are initiated. Are they icon or button-based with lots of step-by-step elements, or they are menu-based programs? The button-based, step-by-step programs are generally very accessible and usable right away. They usually are very strong on easy-to-use basic controls, special effects, and printing capabilities. Even sophisticated power users will use these programs for quick and easy printing jobs or for printing special projects.

Menu-based programs offer more power with greater choices. Power and choices are a double-edged sword. While they allow you to do some very advanced image they also require more time dealing with a sometimes-steep learning curve. Photoshop Elements offers a nice compromise with its Hints palette and intuitive groupings of controls.

Lets look at some of the key photographic features that definitely can affect your printing, features that photographers consistently use with photos on their computers. I'll give you a quick list, and then we'll look more in depth at two very important groups of features and how they can help you make better prints.

15 key features to look for in an image-processing program:

1
Brightness/contrast
Most programs offer a simple set of sliders to adjust how dark or light an image is, as well as its contrast. This is a very intuitive control, although its adjustment has less flexibility than other controls.

2
Levels
A brightness/contrast tool that allows excellent control over the adjustments because you can adjust the dark, light, and middle-toned areas separately.

3
Curves
An advanced brightness/contrast tool that allows great flexibility in the adjustments because you can adjust the many, many tones separately.

4
Layers
A very helpful way of separating parts of an image by isolating them into layers stacked one on top of another; this tool does take some work to understand.

5
Adjustment layers
Layers of instructions that tell the program how to adjust underlying (and unchanged) layers.

6
Layer modes
Unique ways that layers communicate with each other to build new effects.

7
Multiple selection tools
Having a varied group of tools available for selections.

8
Dodge/burn tools
These special brushes lighten (dodge) and darken (burn) small parts of the image.

9
Hue/saturation
A tool to adjust the actual color itself (hue) and its richness or intensity (saturation).

10
Simple color balance control
This refers to a simple slider arrangement that allows you to adjust specific color balances.

11
Clone tool
A specialized select-and-copy tool that moves a piece of the image from one spot to another to fix problems.

12
Unsharp Mask
A highly controllable form of sharpening that includes amount, radius, and threshold.

13
Gaussian Blur
A very manageable, specific type of blur.

14
Multiple picture printing
Printing options that allow you to put more than one picture on a page

15
Templates
Special designs for calendars, cards, and more that let you use your photo in many ways

Refining the Image for Printing— Tonal Adjustments

Most people know of Ansel Adams and his wonderful black-and-white landscape photos. He used to spend days in the darkroom making those images just right. Though Adams essentially only had two controls, he could change the photo's brightness and its contrast. He would "apply" those controls to effect the tonal range of the entire image, or selectively adjust small parts of the photo isolated from the rest.

With just those two controls, he created prints that made him famous. Getting a good print is a craft, whether you do it in the darkroom or with your Epson printer. As you try different adjustments, you'll discover many exciting possibilities with your prints. This is why I really believe that the so-called experts who want to make the process an engineering exercise in computer technology are misguided. Adams always looked at a finished print and studied it to see if it was what he wanted. If it wasn't quite right, he made some new adjustments and made a new print. He often took days doing that. We have the huge advantage of doing this in minutes.

There are three basic brightness/contrast controls: one called Brightness/Contrast (a simple control), Levels, and Curves. You will use all of them at times, although with practice, you will find some controls more useful to your style than others.

The Simple Brightness/ Contrast Control

Every image-processing program that I know of has this control. It is broken into two parts, usually with simple sliders used for the adjustments: Brightness and Contrast. They come together since it is rare that you will adjust one without the other.

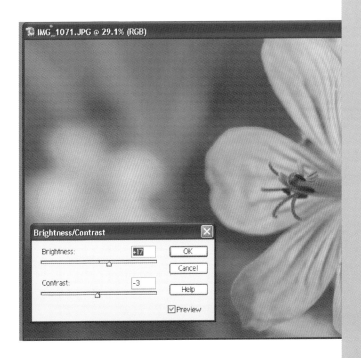

▲ Brightness/Contrast is a simple control available in most programs, which can be used for basic adjustments.

Brightness/Contrast is one of those controls that Photoshop snobs will tell you should never be used. Nonsense! It is probably the most intuitive control for the photographer new to image processing, and it is the quickest and easiest way of adjusting brightness and contrast. You simply make an image brighter or darker, more or less contrasty, by adjusting the sliders accordingly. You make the photo look the way such a subject should look or the way you think your photograph looks best. There is no arbitrary right or wrong, but there is a trick, what I call the Extreme Thing, that does help and is explained below.

Brightness/Contrast will be a control that you will likely outgrow, not because it's bad, but because other controls offer more flexibility over adjustments to your photo. It makes everything brighter or darker, everything more or less contrasty, and has no subtlety to the adjustment. But it does work and can make life easier for you when you just need a simple way of adjusting these parameters.

▲ **Push your controls beyond the normal adjustment ranges so you can get a better idea of what they can do. Crank them to the extreme—you can always "Undo" everything. You can't hurt the image.**

The Extreme Thing

I've found in classes and workshops that many photographers have an overwhelming tendency to make only subtle adjustments to a photo. They ease on through the tweaking process, almost afraid to do too much.

You can't go too far as long as you don't tell the computer to print or save! Take that control and really crank it. See what it will do. Push it to the extreme so you can see what the adjustment really does to a photo. Then back it off to where it looks good.

Form a habit of doing this. Making adjustments that go beyond what you need, then pulling the adjustment back to where it looks good is, I believe, the best way to make first adjustments to a photo. If you tweak a little, then a little more, then a bit more, and so on, each adjustment is so small that you never really see the difference. So you have a tendency to over adjust. Or if you quit too soon, under adjust. Of course you can refine your adjustments to get the best print, but if you haven't taken the "Extreme Thing" approach to start, you'll find those refinements harder to do. Whenever you get stuck and are not sure what needs to be done to a photo, try this "Extreme Thing" technique. It will often be just the thing to get you going.

Levels and Why Black and White Are So Important

A key adjustment tool for photographers is Levels. This may seem a little intimidating at first. After all, it does seem to be more about graphs than photography. Yet, this tool can be the most important Brightness/ Contrast control you have for making better prints.

To understand why Levels can be so helpful, you need to understand the importance of solid black and solid white in a print. All good darkroom printers usually strive to have something pure black and something pure white in their print (the exceptions are gray conditions like fog). These create reference points for the eye. We subconsciously note the pure black and pure white parts of an image to tell us what the tones (the steps of brightness between black and white) of an image are.

A print without both will look dull and gray, without the crispness and brilliance modern cameras are capable of capturing. Epson printers, with their use of a photo-optimized black in the ink set, give an extremely dense black that makes the photos look crisp and rich. However, if your image does not

have a pure black, the printer can't print this wonderful tone.

The Levels control tells us immediately if we have this total range of tones from pure white to pure black. You don't have to be a math expert to figure this out. The graph that comes with Levels, called the histogram, shows the proportions of pixels, from black to white, left to right. The blacks are on the far left and there is a little black triangle below. The whites are on the far right and a little white triangle takes up residence underneath. The rest of the picture is graphed in between—all the midtones.

The histogram needs to start rising on the left and finish on the right. If it doesn't and there is a gap on the left and no part of the graph makes it to the edge, there are no solid blacks in the photo. If there is a gap on the right, so that it doesn't touch the far white side, then the highlights will gray. To adjust, you simply move the black slider on the left, until it is under the start of the histogram, and more the white slider on the right until it is under the end of the histogram.

▲ A good print requires a full tonal range from black to white. Levels helps you set that range. The graph here is called a histogram and can be used to set the black and white levels in a photo. (Compare photos at left and right).

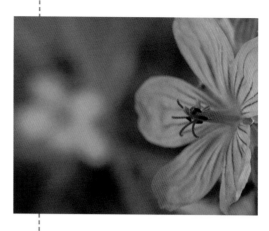

This then can become an automatic way of checking to see if you will have good blacks in your print—always be sure there are blacks and whites in your image by checking levels. You don't have to stop here. You can continue to move the black and white sliders toward the center, either separately or together, to create contrast in your image. The neat thing about levels is that you can create this contrast by favoring the dark areas (left, black slider) or the light areas (right, white slider) in your adjustments.

As you make your changes to the image, the midtones, the bulk of the image, will also change. You can make them lighter or darker by moving the midtone, gray slider in the middle to the left or to the right. This is a very powerful way of dealing with an image. The midtones can now be brightened or darkened, as appropriate to your vision of the subject, without affecting the blacks or whites.

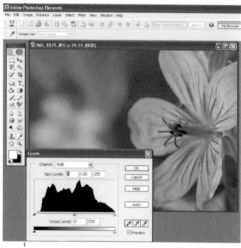

The result of all this individual adjusting is that you can control the shadow, middle-gray or highlight areas without changing the other areas as much. This is a tremendous tool for the creative photographer who really wants something special from his or her prints.

Photoshop and Photoshop Elements offer the Eyedropper tool for help in setting the black and white points, as well as a neutral tone. Although some workers find them helpful, I rarely use them. They seem rather arbitrary to my taste. I prefer to do my own setting of black and white.

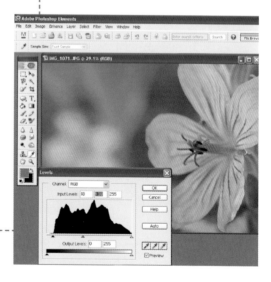

To use levels, first set the black (left slider) and white (right slider) points by moving those sliders to the start of the graph. Then adjust the middle slider (gamma or mid-tones) to make the photo lighter or darker.

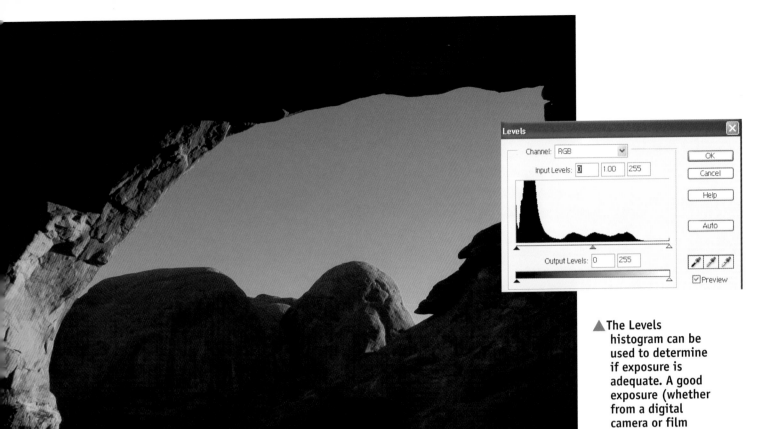

▲ The Levels histogram can be used to determine if exposure is adequate. A good exposure (whether from a digital camera or film that is scanned) makes your work easier and gives better images for printing. The photo above is underexposed and doesn't have the full range of tones or information found in the bottom image.

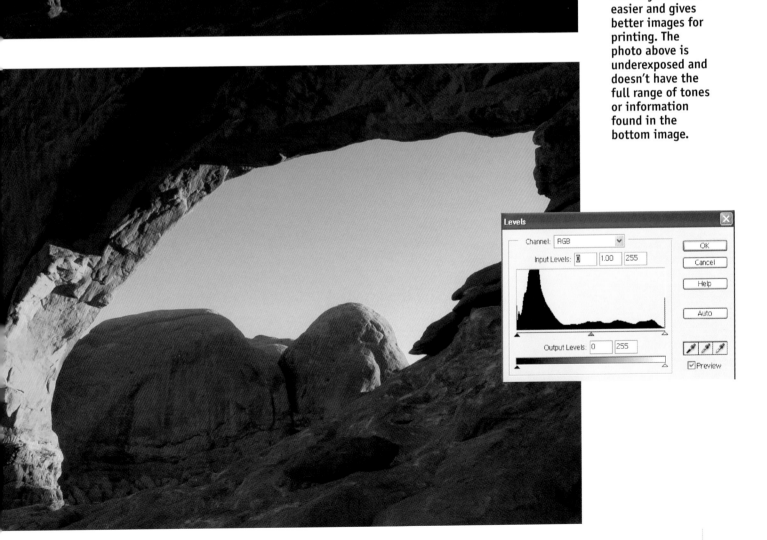

Curves

Curves is another graphic adjustment tool that can help you adjust the brightness and contrast of an image. However, it is one that takes both a little practice and a mental adjustment. It is not intuitive and can seem a little intimidating.

Frankly, while Curves is a helpful tool, the average photographer can go a long ways with Levels and Brightness/Contrast. The advantage of using Curves is that you can do some rather subtle adjustments to fine tune an image in ways that cannot be done with any other tool. Still, I check Levels first, set the white and black parts of the image then check to see what I can do with the midtone adjustment slider. Very often, this gives me plenty of control for excellent prints.

When I feel Curves can help (and this is a subtle understanding that you get from experimenting with the tool), I open it after Levels. Since I have already set the black and white levels (which are the same as the corners of the graph), I concentrate on the mid-tones. I do this by clicking the cursor on the middle of the diagonal line and pulling it up to lighten the midtones or pushing it down to darken (the direction you go can be changed—up to lighten, down to darken is a common default). Usually, you don't need to move it much to see some nice effects.

Now if you wish to favor the dark grays or the light tones you can click again in the lower or upper part (respectively) of the graph. You now drag the curve up or down to affect a part of the curve, which results in a more isolated effect on the tones of the photo. If the curve moves too much in an area that you don't want, click on the graph in that area to anchor it to that point.

You can also make the curve go in different directions, such as, bending the bottom down to darken the shadows and pulling the top up to lighten the highlights. Watch your preview to see how the effect is working. It often helps to turn the preview on and off to compare before and after. As the curve gets steeper, contrast will increase in the image; a flatter curve will make it have less contrast.

Selections

By selecting a specific area of your photo and isolating your adjustment controls to that section, you can totally change whatever is inside the selected area without effecting adjacent pixels (even something right next to the selected area, but outside the selection). You can choose a discreet part of an image by outlining areas with a Selection tool. This can be a powerful control for making that masterful print that needs a little darkening or lightening in one area.

All of the Selection tools can be useful, from the shaped selection tools (rectangles and circles) to the freehand Lassos (which follow your cursor) to the very helpful automatic tools (the Magnetic Lasso and the Magic Wand, for example). With any of these, you move your cursor around the area to be selected and a selection line will appear (some people call this the marching ants). Making good selections can be tricky. This really is an eye-hand-coordination thing that takes some practice.

◀ Curves is a special tool that allows you to adjust specific tones to fine-tune an image. It can isolate changes to light or dark areas of the image.

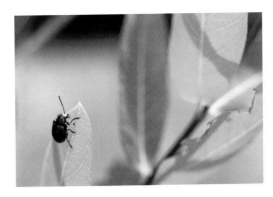

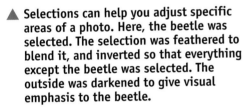

▲ Selections can help you adjust specific areas of a photo. Here, the beetle was selected. The selection was feathered to blend it, and inverted so that everything except the beetle was selected. The outside was darkened to give visual emphasis to the beetle.

Selection tips

1 Enlarge your image, so that you can better see edges of your subject. You need to see in order to determine where your selection should go.

2 Don't worry if the initial selection isn't perfect. You can both add and subtract from the selection in order to refine it. Usually, you will hold down the shift key as you make selections to add to the area, and the alt or option key to subtract.

3 Use more than one Selection tool. Use whatever seems to work best for you, in whatever order you find helpful. Just remember to use the shift or alt/option keys to add or subtract.

4 Look for easy ways to select. If you can use an automatic tool (such as the Magic Wand on the sky), use it to select a background, then invert the selection to capture the desired area.

5 When you have made your selection, feather it. Feathering is a blending or smoothing of the selection edge. Selected edges are generally much sharper than those that would naturally occur in a photograph. Feathering takes that edge off. How much is totally dependent on the photo, so experiment. I find it easiest to control and experiment with feathering when I do it to a selection rather than adding it to the Selection tool.

Dodge and Burn

I mention the Dodge and Burn tools last in this chapter, not because they aren't useful, but because they should be used sparingly to make the final refinements to the brightness and contrast of an image. They were key in the traditional darkroom, but because we have so much control in the digital darkroom, our computer, it is often easier and more effective to darken and lighten parts of an image by using selections.

Dodge and Burn are "painting" tools, meaning that you use them as you would a brush. You must choose the right size brush and how strong you want the effect. Generally, you'll find a setting of 10-15% is plenty. You are better off applying dodging and burning in steps rather than trying to do it all at once. The latter tends to look splotchy and rather artificial. In addition, you can choose whether to favor shadows, midtones, or highlights.

You'll find dodging is great to brighten small areas, such as the whites of eyes or teeth (be careful you don't overdo it, though), highlights in a waterfall or hair, and so forth. Look at your image on the screen first, then your test prints later, to see if you can't make a print a little livelier by whitening some light areas. Use selections to control large areas, as both dodging and burning can look splotchy if done too hard over big areas.

Burn areas that need darkening. This can be very helpful to strengthen local contrast, such as a shadow on one side of your subject or the dark rocks of a waterfall. It can make a subject stand out against a background by either darkening the background around it or burning the subject's edge. Often you will find that, if you make a selection along the edge you need to darken, then use that selection to control your burning, you'll be better able to darken just what needs it. If you then invert the selection, you'll be able to dodge/lighten the other side of the edge as well.

▲ **Dodge tools let you lighten and burn tools let you darken small areas of an image. Here they were used to enhance the flow of the water.**

© Joyce Tenneson, from *Wise Women*

© Joyce Tenneson, from *Wise Women*

Photographer

Joyce Tenneson

© Lisa Devlin

Balancing Assignments and Personal Work

Joyce Tenneson is a highly acclaimed photographer known for her powerful portraits. She has been the recipient of many awards, including the International Center of Photography's Infinity Award. She has also been voted by *American Photo* readers as among the 10 most influential women photographers in the history of photography. And she has achieved commercial success, with cover photos for magazines such as *Time, Esquire,* and *Premiere.*

Tenneson has a unique style that requires an ability to capture subtle nuances and feels the Epson printers deliver. "I use Epson printers as tools to achieve my artistic vision. The prints that are produced can include nuances that differentiate a good photograph from a great photograph. In addition, having a quality printer in the studio gives me the freedom to try out different things, and get the best image I possibly can. I have infinitely more options now than I did before."

She began working with Epson printers over five years ago, and now relies heavily on them, using both desktop and wide-format models. Beyond their incredible image quality, they also provide the permanence she needs for her fine art photographs.

Tenneson also feels the Epson printers are versatile. When asked which type of work she uses ink jet prints for, she responds with enthusiasm, "Everything! I deliver aim prints to clients and produce prints for exhibition." Epson printers were also involved in the production of her most recent book, *Wise Women.*

Like all pros, she feels that the photo paper used in the printer makes a big difference in the prints, and her soft tonalities often lend themselves well to papers that are not glossy. She especially likes the Epson heavyweight matte papers.

There is no question that, for Tenneson, Epson ink jet printers have revolutionized her studio. She believes they have given her more control of the technical part of the process, freeing her up to concentrate on her creativity. As she puts it, "Ink jet printing will take over the photo industry."

Tenneson's work can be seen at:
www.joycetenneson.com.

Refining the Image for Printing–Color Adjustments

In the traditional darkroom, black-and-white was king. While you could adjust a color print, it was hard to do. It required the use of toxic chemicals, had to be done in total darkness, and would take a substantial amount of time. Getting a good color print was sometimes a challenge, even when you went to a lab. In addition, many people shot color slides (especially the pros), which could be printed as photographs, but not all labs did a good job with them.

So, many photographers got the idea that color could not be changed. You picked the film you liked and just went with it. Wow, has that idea become outdated. With the digital darkroom, we have wonderful control over color, and as we saw in the last chapter, it starts with Brightness/Contrast controls. You could never change a color print before as we can today with the controls available in Levels.

Color and the "Good" Print

What is good color in a print? Something that matches what's on the monitor? Not necessarily. Color that matches what's on a slide? That doesn't mean it's real. Color that looks real? Sometimes. How about color that is pure without being muddied by unwanted colorcasts?

I believe that good color in a print is color that satisfies you and your unique rendition of the subject. A scientist who needs precise matching of hues to the real-world subject will have very different needs than a wildly creative artist-type who pushes the limits of photography. Probably most of us fit somewhere in between.

Regardless of where you are on such a spectrum, you know better than anyone else what you like. Or if you are making prints for someone else, you certainly have a better feel for what they like than any "expert." I say this because it is all too easy to hear "experts" telling you that you have to adjust your photo a certain way, that you have to match specific color requirements and so forth. The sad thing is that, some photographers get so unsettled by such pronouncements, they get disheartened by their own efforts and don't enjoy their printing.

Printing should be fun and playful. That's always been a part of creativity and certainly printmaking with an ink jet printer should be creative.

Here are some ideas you can use to evaluate the color of your image on screen and when it is printed.

1 **Remove annoying colorcasts**—Colorcasts can be beautiful, such as the golden tones at sunset, but they can also be a problem with photos, when the colors annoy you and distract from the subject. A picture can pick up such colors from the light (such as fluorescent), the scanning process, or even digital camera bias in certain lighting conditions. This cast is usually most noticeable in neutral colors such as gray and white.

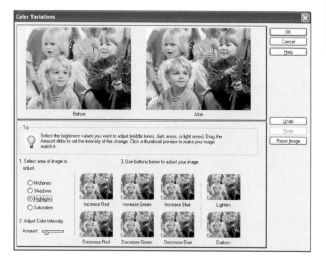

▲ **Often, key colors are the most important part of a print and need the most attention to getting them right.**

2 **Evaluate key colors**—Often you will find that certain colors dramatically impact the print. Their effect on the photo is far greater than their relative portion of the image. Examples might be a particular blue sky, a patch of yellow flowers, the red in a soccer player's jersey and so forth. These are colors that are very important to the subject, to the composition, to the mood, or any other aspect of the photo. They are so important that, if this color were missing, the photo would not work. These key colors are well worth spending time adjusting.

3 **Watch out for contaminated colors**—Some colors are more susceptible to contamination than others. By contamination, I mean that the colors become less pure and pick up other hues that really don't belong. You can look for contamination in any color, but the following colors tend to exhibit this problem: yellow (yellow degrades quickly to green or red), blue sky (often picks up too much red), blue flowers (film is over-sensitive to ultraviolet light which tends to make blue flowers too red, or purple), pale colors (these are often influenced by other nearby colors), and dark green (this can pick up red which makes it dark and muddy).

▲ **Strong colorcasts can result from many lighting conditions. Color Variations or Color Balance controls can help you correct them.**

4 **Consider the vividness or saturation of the colors**—Colors make us react in part because of their emotional quality. That often is the result of the saturation of colors, how vivid the color is. You can find colors that are too vivid (say a red wall behind a woman with strawberry blonde hair—the red wall will overpower the hair) or you can also find colors are too dull (for example, brightly colored flowers on a gray, cloudy day).

5 **Evaluate color rendition**—The difference between vivid and muted color prints is not just a matter of subject but more of personal style or taste. Some people consistently prefer more vividly colored prints, while others want something gentler. Neither is correct, but once you realize that you have such preferences, you can work to make your prints consistently express them.

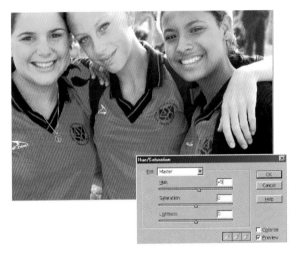

6 **Compare color relationships within the image**—Colors rarely are seen on their own. Almost always, they interact with other colors around them. Consequently, they interact with each other in your photo. Look at them. Is a red overpowering gentler colors? Are grays too light and pulling color out of an isolated subject? Think about how the image would look if certain colors were made stronger, weaker, or different. One powerful change is to increase the color saturation of foreground colors, for example, and decrease the saturation in the background.

7 **Consider what looks real**—You've probably heard people say that a bizarre news event could never be made into a movie because no one would believe it. This actually happens in our photos, too. Your print may actually look just like the slide, and you may believe the slide is an accurate rendition of the world as you saw it. Still, a photo must "read" as real, meaning the viewer must believe it is real, if that is the result you want. You'll sometimes find that some colors just don't seem to have a real feel to them. Trust your intuition and adjust until you are satisfied.

8 **Consider color alternatives**—Sometimes it is fun to make photos with wild and exotic colors. Go for it! Have some fun with alternative colorings of your image. However, to be effective, you generally need to make strong changes in the colors. Subtle differences with alternative colors will look more like a mistake than a creative choice.

◀ **Colors don't always photograph or print true to the original. Hue/Saturation can help you adjust them.**

Hue/Saturation

Almost every image-processing program lets you affect hue (the actual spectral color) and saturation (intensity). Usually, there will be a slider control for hue, which allows you to change colors. You can get wild effects with this. You can also select a specific part of a photo, for example, a red flower, and adjust its hue, or even change the color altogether.

Saturation is a key color tool. This allows you to change the intensity colors. You can adjust the whole photo to make colors more or less saturated. It is not unusual to find that you like a print to have a different saturation than what you like on the screen. That is the nature of prints. In addition, you will find that different papers give different color renditions, especially in the area of saturation, so this control is always helpful.

Over the years, photographers have been drawn to the brighter, more intense films, both slides and prints. Kodak even markets a film called Extra Color. Yet, digital cameras often produce files that print with less color intensity. Try bumping the saturation up 10-15% and see if that helps.

The Hue/Saturation adjustment window usually includes a "Lightness" setting as well, which should be used only for slight tweaking of colors due to changes in saturation.

In a number of programs, you can actually isolate the Hue/Saturation adjustments to a particular color. In Adobe Photoshop and Photoshop Elements, for example, you can click next to where it says Edit: Master and a drop down menu will appear with specific colors. If you then move the cursor onto the photo, it will turn into an Eyedropper. Click on the appropriate color in the photo and the adjustments will be specific to that color.

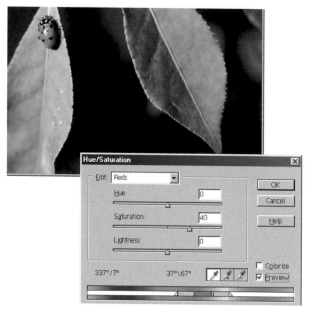

▲ You can control how a viewer looks at your print by adjusting color saturation in the Hue/Saturation dialogue box, even down to adjusting mainly a single color.

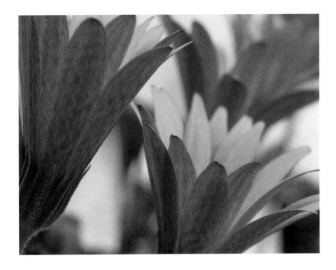

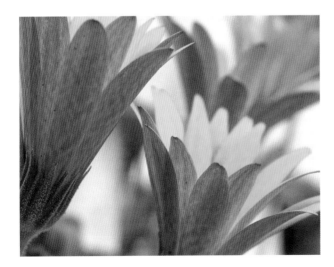

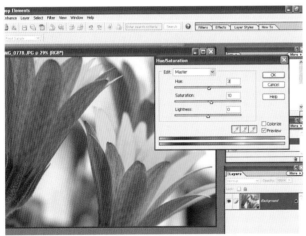

▲ Digital cameras often need a slight boost in color saturation. Try adding 10-15% to start.

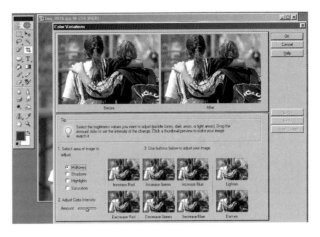

▲ Variations uses visual references to help you adjust color. Just click on the photo you like among the color adjustment choices.

Color Balance and Variations

Frequently, a photo will be just a little off in color, sort of like a song that is sung slightly off key. It will never print satisfactorily. Color Balance controls and the Variations adjustments available in many programs can definitely come to the rescue.

Color Variations in version 2 of Photoshop Elements is a very intuitive set of controls that uses three thumbnails to control the amount of red, green, and blue in a photo. You can set the adjustment window to favor shadows, midtones or highlights. The thumbnails are set up to add or reduce the computer colors, red, green, and blue (RGB). You'll often find it works best with the intensity set low.

In Color Balance, sliders control the amount of red, green, and blue intensity in a photo. Again, you can set the adjustment window to favor shadows, mid-tones, or highlights. The sliders are set up with opposite colors—cyan to red, green to magenta, yellow to blue—or they are set up to add more or less of the computer colors, red, green, and blue (RGB).

Either way, just click on thumbnails or move sliders to make the colors look more like you expect them to look. There is no right or wrong to this. The key is to look at your image on the screen, then later as a print, and think about how it appears to you. I strongly recommend using the Extreme Thing technique, described in the previous chapter, to see what colors need most adjustment.

▲ The colors of a photo can be rendered as neutral, warm, or cold in tone. For many images, the warm tones are most appealing.

Either color balance control is especially useful with photos shot in the shade or on cloudy days, when the light is mixed, or under fluorescent lights. Frequently, images shot in the shade or on a cloudy day, lack warmth, although they may or not look overly blue. In this case, add yellow and red (or remove blue and cyan) until the image looks right to you. Skin tones, especially, start to glow nicely with added warmth.

When the light is mixed, such as a photograph taken near a window, that also includes light from an incandescent lamp, colors can appear unreal in pictures taken with film or digital cameras. You may even find that part of the photo is too warm while another part is too blue. In this case, you need to make a selection of one area at a time, feather the selection (this smoothes the edge), then adjust the color balance of the selected area.

Fluorescent lights have an incomplete spectrum of color, and tend to cause a greenish cast in pictures shot with film. With digital capture, fluorescents can either give sort of natural color (which may be okay or require only minor adjustment), or they can make a photo look way off (often too yellow). Again, either Color Balance or Variations can help; although you may really need to go to the "Extreme Thing" technique to zero in on the correction needed. Subtle adjustments can be difficult to assess.

Test Strip

An excellent program for dealing with color adjustments is VividDetails Test Strip (www.vividdetails.com). This is a Photoshop-compatible plug-in. That does not mean you have to use Photoshop, since many image-processing programs, including Photoshop Elements, accept these plug-ins. A plug-in is a specialized software program that fits inside another one. The image-processing program is the "host," so-to-speak, and must be open in order to use the plug-in.

Test Strip is a superb printing tool and I'll talk more about its uses in dialing in the perfect print in Chapter 9. It is also a very intuitive and powerful color adjustment tool. It is like Variations, Color Balance, and Saturation controls all in one,

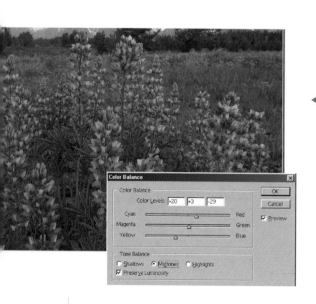

◀ Add the effect of using a warming filter by increasing the red and yellow in the photo through Color Balance.

▲ VividDetails Test Strip makes color adjustments a visual "select-and-click" choice.

with a very flexible interface. You get a variety of color thumbnails to choose from that are totally adjustable and can be customized. You can tell the program what colors you want to work with, what part of the photo to look at, and whether to adjust overall or mainly in the shadows, midtones or highlights. In addition, you can set the program to show you what colors need to be added or subtracted, and the amount of change can be very precisely controlled.

Layers: New Possibilities of Control

The key to understanding layers is to realize that they separate your adjustments into distinct and isolated pieces of an image. Think of it as putting a stack of identical photos on your desk. Each photo is a layer in that pile. When you look at the stack from above, you only see the top photo. Cut a piece out of that top photo and you can see some of the photo under it. If you keep cutting pieces out of photos as you go down through the stack, you'll be able to see parts of the lower images. If you do something to the photo under a solid layer with no cutouts, you won't see the effect, as the top photo hides it.

To get started using layers, try Adjustment Layers. This can be very helpful with printing, because it allows you to adjust what a photo looks like without changing the underlying photo. Plus, it allows you to go back later and readjust if you don't like the effect on the print. There actually is nothing in an adjustment layer except instructions. These instructions can be set to affect Brightness/Contrast controls as well as color. And since Adjustment Layers always work from the top layer top down, they affect whatever is underneath them. However, if an Adjustment Layer is removed, the original image remains.

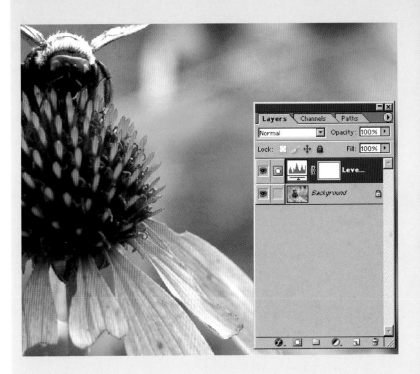

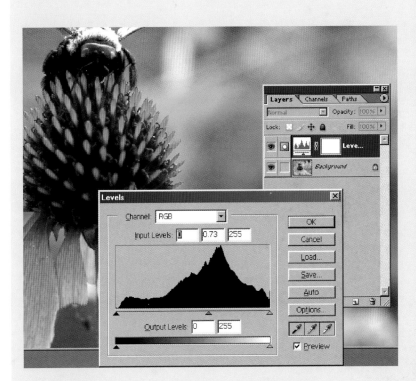

▲ **An easy way to get started with layers is to use an Adjustment Layer.**

Adjustment Layers are excellent to use in refining an image for printing because even after adjusting once (top), you can go back and open the same tool and readjust as much as needed without adversely affecting the image.

You may also find Duplicate Layers quite helpful for printing. These are layers with identical images in them, like a stack of photos. You can experiment and try different effects on the various layers and compare them fairly easily, because all the layers are right there on your computer desktop. Since duplicate layers are separate, anything you do to one has no effect on the others, and you can compare them quite easily.

A

One of the best ways to use duplicate layers is to work with different layers for specific parts of a photo, then cut out the unneeded parts on each layer. For example, here you see a landscape photo with "ground" (foreground with plants and soil) and sky (**A**). Each area needs to be adjusted separately, so that the image prints well. You could simply select each area and adjust, but the disadvantage to that is in your ability to balance these areas. As you adjust the sky, you may find the ground needs to be readjusted to balance the tones of the sky. This can be done but is harder when everything is in one piece.

B

Duplicate the image twice so that you have three layers counting the bottom (the safety layer on the bottom stays unchanged). Consider the layers from top to bottom the same as the photo: sky on top and ground on the bottom. Adjust the sky so it looks good, ignoring what happens to the rest of the scene (**B**). Then remove or cut out everything but the sky and distant mountains in that layer (**C**). You can do this by: using the Eraser Tool; selecting everything but the sky and deleting it (make sure you feather the selection); or using a Layer Mask if your program has that capability.

C

Do the same thing for the ground layer (**D**), making this part of the image look its best. You don't need to remove the sky part of this layer because the top layer, the sky, is covering up the ground layer's sky. You can make some final tweaks to the image to adjust where each layer has its main effect by removing small segments as needed. You now have a complete image made up of separately adjusted pieces or layers (**E**).

D

E

Because layers are separate entities, you can go back and tweak any layer, affecting only that part of the photo, which can be very helpful as you are refining a print.

Here are a few things to think about and try as you experiment with layers:

1 **Combine selections with layers**—You can select something from one layer and copy it to another. This gives you the chance to work on these sections separately, just as when you use selections directly on the photo; except now the selection is totally separate on a new layer.

2 **Rename layers**—As you work, give each layer a distinct name appropriate to it (on the latest versions of Photoshop and Photoshop Elements, you just double-click on the layer name). This will make it easier for you to find and work on a particular layer.

3 **Use the Multiply mode on weak or washed-out images**— Duplicate the image onto a second layer. Then change the layer mode to Multiply. This will intensify the washed out image, often making it print much better.

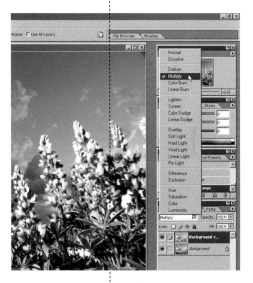

▶
The weaker image at top was intensified to create the one at right by adding a layer (either a duplicate or adjustment layer) and setting the layer mode to Multiply.

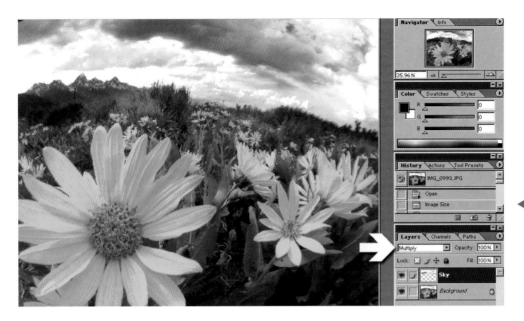

◀ The Multiply mode works very well to bring out drama in skies.

4 **Use the Screen mode on too-dark images (or parts of images).** Copy a dark photo to a new layer. Now change the layer modes to Screen. You'll often be pleasantly surprised at the detail you can bring out in the dark areas without making it overly gray.

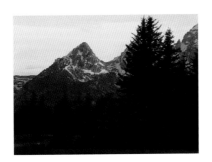

© Pete Turner

Photographer

Pete Turner

Maestro of Color

Pete Turner is considered one of the great masters of color photography. His graphic color compositions have found their way into everything from high-end advertising to books and galleries.

Turner started working with Epson printers a few years ago. He immediately started using them for proofing his work for publications. He has steadily upgraded his units and now uses both desktop and wide-format models. He prefers to use paper with some weight, a matte or luster finish, not glossy, and is always experimenting, looking for papers that best express his graphic color sense. And although he continues to use the printers for proofing images, he now also uses them for making fine art prints for collectors and galleries.

Turner is extremely happy with the quality he gets from his printers. That's a far cry from how he felt working with photo labs, since he was often disappointed in the results. To get around the problems, he developed his own proprietary system for getting the colors he needed, a process that was both tedious and laborious. Now, using Epson printers such as the Stylus Photo 2200 and Stylus Pro 7600, he's been reborn in his passion for experimentation and precision. What's more, he's happy with the longevity of the Epson prints, since his business relies on the prints lasting a long time.

He feels that a digital darkroom that includes Epson printers is a tremendous tool for the photographer. "It's one thing to look at a photo using a monitor, but quite another to sit down with a large print in front of you. You see things more clearly, including things you might otherwise miss. Then you can make the photo better, enhance it, check again and make it even better. An Epson printer gives color photographers a darkroom right in their studio with virtually instantaneous results."

Turner feels that photographers and Epson are on a great path for the future. "Epson is moving at light speed," he says. "These printers are incredible."

Turner's Web site is www.peteturner.com.

Finishing Touches

What separates a good print from a really great print? There are lots of things, including: paper, printer settings, brightness/contrast, and color adjustments, all of which we've covered. In addition, there are some special finishing touches that you can do to your digital image file that will add that extra something to make your print really shine.

Grain Management

Grain has been with photography since it began, but became really important when film formats were reduced with the birth of 35mm. Sometimes we find we have too much grain in an image, yet other times we increase grain for creative effect. Either way, grain has a strong impact on how a print looks.

Visually, "noise" in a digital image file is essentially the same as grain. The irregular speckled pattern of either can be distracting and can even destroy a good photograph. Worse, we may inadvertently increase or enhance this grain while working on a photo in the computer.

Here are 10 common places for grain or noise to rear its ugly head in our photographs and ways to reduce it:

1 Film grain

A general rule is that higher speed films have more grain than lower speed films (e.g., ISO 400 compared to 100). The grain in film can also be affected by processing. **Solution:** Use fine-grained films whenever you can. The best are those with a film speed in the ISO 100 (or lower) range.

2 Sensor noise

Digital cameras pick up grain effects from noise off the sensor, mostly in low light. Night scenes can be a real challenge for many digital cameras. Higher ISO equivalents for image sensors also increase sensor noise. **Solution:** Shoot in bright light and restrict the use of higher ISO numbers (ISO equivalent of 400 or more) to minimize noise from the sensor. You have no control over the sensor itself (although more expensive digital cameras usually control noise better).

3 Exposure

Underexposure causes increased grain in color print films. Digital camera sensors don't like underexposure either and may kick in noise. **Solution:** Be sure the exposure is adequate. This is especially critical in low light and when shooting light, highly reflective, or backlit subjects. Add exposure or use a flash if needed.

4 Scanning

Low-priced scanners can be very susceptible to noise, especially in the dark areas of an image. In addition, you'll find differences among even the most expensive scanners in the way they capture film grain. Avoid the really low-priced units, as they tend to pick up a lot of noise in the dark areas of an image. **Solution:** Make a quality scanner a priority item when purchasing your set up.

5 JPEG artifacts

Too much compression when saving to a JPEG file, or repeatedly opening and saving a JPEG image, can create little blocky details that look like chunky grain. This is most apparent in same-colored areas with slight gradients of tone such as the sky. **Solution:** Use JPEG (a compression format) sparingly and don't use it as a working format in your image-processing program. Set your camera to its highest quality compression, even though that does mean larger file sizes.

6 Digital artifacts

Sky can be a problem for digital cameras, especially lower-priced cameras or those with fewer pixels. Sky tone varies in a subtle gradient from horizon up. A sensor must make sense of that gradient, yet it can only deal with bits of it at a time (via pixels). This can cause a grain-like pattern in the sky. **Solution:** Realize that subtle gradients may emphasize grain. When sharpening the photo, avoid plain sky areas.

7 Out-of-focus areas

Out-of-focus areas tend to emphasize grain or noise in an image. **Solution:** Remember that out-of-focus areas and large expanses of one tone emphasize grain. If necessary, select the sharp areas and separate them from the rest of the photo before sharpening the image. Never sharpen out-of-focus areas.

8 Image-processing software

Your image-processing software can amplify the appearance of grain or noise. Hue/saturation, for example, can dramatically bring out undesirable grain/noise effects in the sky. **Solution:** Avoid over-processing of the image.

9 Sharpening

Indiscriminate sharpening and oversharpening can enhance grain and noise to the detriment of a photo. **Solution:** Avoid oversharpening the photo. Sharpen only the sharp parts of your photo.

You will never completely eliminate grain with standard photographic procedures. Sometimes grain can be interesting and can even add to the sharpness of a photo. This is why you can't just blur out grain—it may be needed to keep a photo looking sharp, especially in key areas of the image.

Sharpening the Image

For a print to look its best, the image file usually has to be sharpened. This has nothing to do with making a fuzzy or blurry image sharp. What sharpening does is bring out the sharp details in the file. The scanning process, in particular, does not result in the final sharpness needed in an image, even though detail is there. Digital camera images also typically need some sharpening. One key reason for this is that image processing often affects the appearance of sharpness, so image-processing pros have long sharpened at the end of the process.

The best sharpening tool is the Unsharp Mask, which in spite of its name, gives us a great deal of control over sharpness. (The name is actually a relic from the commercial printing industry). This tool has three different controls that can be adjusted separately for optimum sharpness (although, truthfully, sharpness is a subjective quality and "optimum" will vary from photographer to photographer).

Once you open Unsharp Mask, you'll discover a window with sliders that control the Amount, Radius, and Threshold. Some programs use slightly different terms, and a few even offer only the first two, but they all work similarly. You will find all sorts of formulas for these numbers. I will give you some numbers and ways of setting them that will work and you can experiment from there.

Amount is probably obvious—how much sharpening you apply. This is the intensity of the sharpening effect, which increases contrast along edges of elements in the photo. Usually you'll want something between 100 and 200 percent in Photoshop and Photoshop Elements (this range does change from program to program—experiment with the lower range of numbers). Usually going beyond 200 will add harshness to the image (including the appearance of white rings around edges). Typically, I find that scanned images sharpen well in the 150-200% range and digital camera photos look good in the 100-120% area.

Unsharp Mask

OK

Cancel

☑ Preview

50%

Amount: 120 %

Radius: 1.0 pixels

Threshold: 0 levels

▲ Be careful not to over sharpen a
photo (above right).

◀ Use selections as needed to only sharpen what needs to be sharpened in a photo.

◀ Grain is a problem if out-of-focus areas are sharpened too much. Set Threshold higher on Unsharp Mask to reduce grain or noise "sharpening."

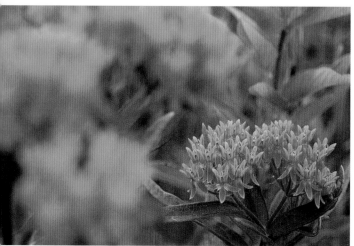

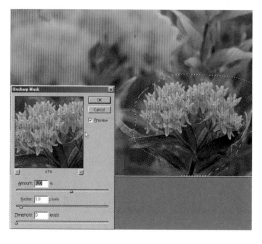

◀ Or, you can sharpen only specific, selected parts of a photo.

Radius determines how much of an edge change is used in order to make the sharpening effect. Generally, I find this most effective in the 1-2 pixel range, using lower numbers (they can be set as decimals) for smaller file sizes (say 10 MB or less) and the higher numbers for larger files. For very big files, you can increase the Radius accordingly. Again, watch out for over sharpening, which adds harshness to the image and the rings of white around edges (called ringing).

Threshold tells the program at what contrast to look for differences along edges. Low settings give the most sharpening effect—if you can use 0, go for it. However, Threshold is very important when you have grain or noise in an image. A low Threshold setting will cause the program to sharpen and therefore overemphasize that grain and noise. Typically, a Threshold between 5-12 works well and minimizes grain problems, but you will have to increase the Amount setting.

If the controls seem intimidating, you can try a handy plug-in from nikMultimedia called nik Sharpener Pro (www.nikmultimedia.com), which uses Unsharp Mask techniques, but hides them behind a user-friendly interface. Sharpener Pro automates some of the process and is designed to optimize sharpness for a particular size of print. It is a Photoshop-compatible plug-in, so it works with many programs that recognize this standard. It uses very understandable sliders, such as paper type and size, to control the sharpness.

Edge Burning

Early in my photographic career, I sat down and read all of the Ansel Adams books on photographic technique. I found a lot of great information. Adams was a superb printer. If you ever get a chance to see one of his photographic prints at a museum, you will see the work of a true master. His books cover the art of printing in detail.

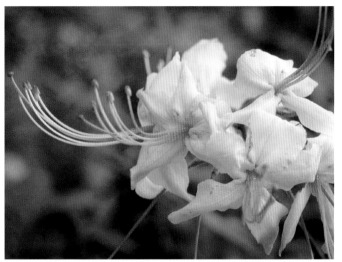

▲ **Edge burning darkens the edges of the photo (as seen in the lower image) before printing. This technique is an easy way to make a print look more dramatic.**

One important factor that Adams stressed was controlling the brightness of the edges of the print. He felt, as have many master black-and-white printers, that the edges should be darkened to keep the eye in the photo. Adams would spend time on most photos burning in (darkening) some or all of the edges to refine his print. Although I have seen some of his prints that had very heavy edge burning, Adams did it so masterfully that most people don't notice this technique.

For "edge burning" our prints, we don't want to use the Burn Tool available on many programs. This is a great tool for tweaking small areas of an image, but the Burn Tool may look blotchy when applied to a large part of the image.

The technique I will describe will give you edge darkening that is never blotchy and is actually easier to do than using the Burn Tool. You simply select the outside of an image and use the Brightness/Contrast control to darken it. Here are the steps:

1 Select the outside of the photo
Use a freely moving selection tool such as the Freehand or Polygonal selection tools for most flexibility. For a more automated approach, try the Elliptical tool. Select around your subject, staying a little away from its edge. There is no absolute with this. You have to experiment to see what you like best.

2 Invert the selection
Your selection was made around the print (meaning it is included and the edges excluded). Since you want a selection that includes just the edges, invert the selection (in the Selection Menu).

3 Feather the edge
Make a very big feather (or blending) of the edge—at least 70-80 pixels and something over 100 wouldn't be out of line. This will vary depending on the photo, how much blend you like, and the image size (**A**).

4 Now you have several choices:
• **Use the Brightness/Contrast control** to darken the selected area—Over adjust it at first so you can see the effect, then bring the control back until it looks natural (**B**). Now, turn the preview on and off and you will be amazed. The undarkened image just doesn't look right!
• **Or use layers**—Copy the selected area to a new layer then adjust Brightness/Contrast for it. This gives you a little more flexibility and control as you can also adjust the layer opacity for effect.

• **Or use adjustment layers**—Use a Brightness/Contrast Adjustment Layer with the selection (which will usually create something called a Layer Mask) to darken the outside of the image.
• **Or use a filled layer**—Again in layers, you can add an empty layer, then fill the outside selected area with black. Change the Layer Mode to Multiply, then bring the Opacity of the layer way down, probably 10-15% (this is highly dependent on the photo).

All of these work. There is no absolute best. You may find you like the ease of one or maybe the control of another. The last effect does have a slightly different look.

A

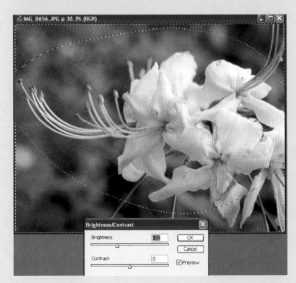

B

Borderless Prints

Borderless prints from the local minilab have become a standard. You can duplicate this look with any printer by using special borderless papers. These allow you to print over a perforated edge, which is then removed to make a borderless print.

However, a number of Epson printers make this even easier with their BorderFree™ technology that allows you to print edge-to-edge, borderless images without trimming the paper. You can't do this with all papers; your manual (and the Epson Web site) will tell you which papers support borderless printing. You do have to be careful of thin papers, as the ink can over-saturate the edges. Borderless papers and printer capabilities are available from 4 x 6 to 11 x 14 inches.

One really great way to go borderless is by using an Epson printer with roll paper capabilities. You can set up a whole series of photos, such as an entire folder done in FilmFactory, or by queuing up print after print in any program. Then print 4 x 6 inch prints continuously on the roll paper. Some printers even include an automatic cutting feature.

Borderless printing is fairly simple as long as you have the right paper. In Windows, open the printer and select the right paper in the driver, then set the mode to PhotoEnhance or Automatic.

Then click on the Paper tab, select Sheet Feeder as the paper source, then click the No Margins box. Be sure you have the right paper size, too. The click OK.

For Mac, the process is similar. Select File>Page Setup. In this dialogue box, click on No Margins. Be sure the paper size is correct and Auto Sheet Feeder is selected. Click OK, then go to File>Print, choose the correct paper type, then set the mode to PhotoEnhance or Automatic, and Print!

With roll film printing, obviously this is a little different. You need to be sure Roll Paper is chosen and not Sheet Feeder.

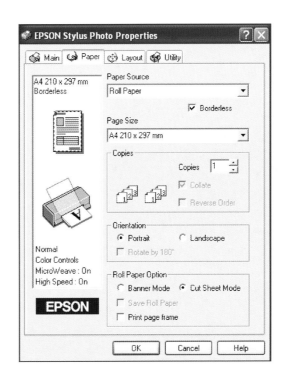

▲ **Borderless prints are possible with many Epson printers. You do need to set the printer driver correctly to tell the printer to print that way.**

Unique Borders

Special borders often enhance and complement photos that you want to hang on the wall or use in unique displays. I am not talking about the standard photo white border here, but a unique border you can add to the image file itself for the effect. The actual edge of the photo is affected in the file, and therefore, in the print.

I'm going to cover some simple borders that can quickly and easily be applied to enhance your print. You can create additional borders with variations on these techniques. It is interesting that some of the low-priced programs, such as Microsoft Picture It!, include rather elaborate borders that can make the program worth purchasing for that purpose alone. In addition, there are plug-ins devoted to borders, such as PhotoFrames from Extensis (www.extensis.com).

Black Line and Colored Borders

A very easy border that often enhances a print is a simple black line around the image. This is especially true for light images or photos that have large areas of white near the edge of the frame. In addition, a simple black line border is an effective way to define the area of a photo on a page.

There are many ways of doing this effect. Here are some:

1 **Border command**
 Select the entire photo (Ctrl/Cmd A). In the Select Menu of Photoshop and Photoshop Elements there is a Modify command. Under that you'll find Border. Choose that and set a border between 1-4 pixels (this varies with the size of the photo and your taste—small photos need the smaller pixel dimensions). Fill this with black and remove the selection.

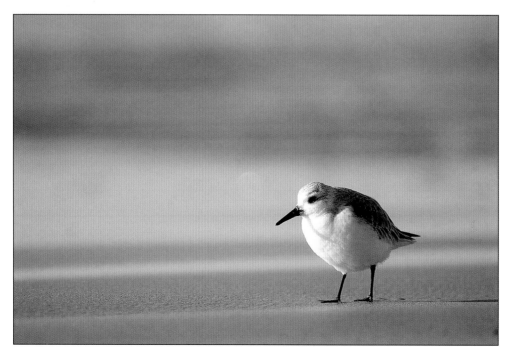

◀ **A simple black line can be an easy, yet elegant way to define the edge of a photo.**

2 Border painting

Choose your paintbrush tool. Select black for the color and a hard-edged (very important) brush between 1-4 pixels. Click the cursor once in the upper left corner of the photo (as far as you can go without leaving the image). Hold the Shift key down and move the cursor to the upper right corner (as far as you can go). Click again and a line will form across the top of the photo. Holding the Shift key down, click again in the lower right corner, the lower left corner and the upper left (where you started) and the border will follow you.

3 Outer selection

Use the rectangular selection tool. Make a selection that starts close to, but not at, the upper left corner, then goes close to, but not touching, the upper right, then close to, but not touching, the lower right (the lower left is included automatically). Invert the selection so the outer edge of the photo is selected and fill with black.

Use the same basic techniques to create a colored edge border. This can be very effective if you select a color that is in your photo. You can also use holiday or seasonal colors for an image that might be used in a greeting card. Color effects often look best with a bigger border than what is used for the black line technique. Select a border size (or paintbrush) of 5-10 pixels. The rectangular marquee can also be used to make a wider selection around the outside of the photo.

These techniques do cut into the photo. With a narrow line, as used with the black line technique, this usually doesn't hurt anything. However, with wider colored borders, this can be an issue. In this case, you may need to enlarge the "canvas" of the photo, which will make your photo file larger to allow a border, but will not change the actual size of the image.

In Photoshop and Photoshop Elements, you increase the canvas of the photo under the Canvas command. There you add a little size to the photo (adding pixels or fractions of an inch), keep the photo centered on the canvas, and click OK. This will add a border that is the color of the background. If you do this and the color isn't right, just use your Magic Wand selection tool (the one that selects things based on a single click on the photo) set to a low tolerance. This should select the border area quite well. Then add your color.

Drop Shadows

For a unique and fun photo effect that adds some dimensional qualities to your print, try a drop shadow. Some programs will do this automatically (there are drop shadow layer styles in both Photoshop and Photoshop Elements). However, there is an easy and highly flexible way of doing drop shadows that I like to use. Here are the steps:

1 Add a duplicate layer to your image file (copy your photo to a new layer).

2 Increase the canvas size of your photo to add about an inch, more or less, all around the photo. Experiment and see what you like.

3 Fill the bottom layer with white.

4 Make a rectangular selection around the photo (Ctrl/Cmd click on the layer will do it for several programs).

5 Add a blank layer on top of the layer stack.

6 Fill the selection with black on the new layer on top. You will now see a black rectangle.

7 Deselect.

▲ **Drop shadow**

8 Move the black rectangle layer down one layer in the layer stack so that it's below the photo layer. This will now be the drop shadow layer and can be named as such. The photo will now appear.

9 Be sure you are on the black rectangle layer, then move it so the black starts to show on the right and lower edge of the photo above. You can actually make this shadow appear on any side, having it on the right and bottom fits a convention that the average viewer can easily relate to. Move it until it seems to create the shadow effect that you like.

10 Blur the drop shadow. Gaussian Blur is the best as it is most controllable. Blur the black box until it looks like a nice shadow edge.

11 Lighten the shadow until it looks good to you by using the Brightness/Contrast control (you don't need any other tools, as there is no range of tones to deal with).

You can use colors for this shadow for special effects or to make a shadow that seems to go better with the photo. Add this color to the selection instead of black. Sometimes a subtle change works well, such as using warm or cool black for the shadow.

Fancier Edge Treatments

The potential for variety and creativity in edge effects is great. I'll give you some ideas that you can take and try, but be careful that the border does not overpower the print. I've seen subtle colors in a photo get lost because of a too-brightly colored border. The bottom line is, go for the simple. Photos tend to be complex enough without overburdening them with overly detailed borders. Now, let's look at a few easy-to-do, simple edge treatments:

1 **Painted On**

Take a hard-edged paintbrush with white as the color, and then paint the edge of the photo with an irregular, almost jerky, movement, always staying at the edge. This will make a unique, one-of-a-kind edge that will sometimes look great. Be sure you save the image as a copy first, so you apply the effect to the copy. Experiment with different sizes and types of brushes for varied effects.

▲ **Painted-on edge with drop shadow.**

▲ You can use a photo as an edge treatment for an image by putting a larger background photo on a layer under your main image.

2 Painted On Layer

You can do the same effect as in 1 with more flexibility by using an empty layer over the photo. Paint the edge treatment in that layer. You can then go back and change the edge treatment in the layer. In addition, you can add effects to this edge treatment by experimenting with the choices in the Filters or Effects part of the program's menu and applying them to the edge layer.

3 Photo-in-Edge

This technique actually uses another photographic image (often a texture) as the edge of the photo. A very nice way to get this edge photo is to use a flatbed scanner to actually scan something, such as the pattern of leaves, fabric, or any photograph of a texture or pattern. You start with the textural edge photo as the base. Then you copy your main photo and paste it in as a layer over the texture. You could also paste it into a selection that was in the right spot. Size the main photo so that the textural background shows up as a nice border. The amount of border you decide to show will depend on its texture and what looks best with the photo. A black-line border, or a drop shadow, can add to the overall effect. Ideas: A flower photo with a border of leaves, a birthday party with an edge of balloons, a seascape with a border made from a close-up of the rocks along the shore.

◀ Soft edge

4 Soft edge

This is a very romantic photographic treatment that often looks good with portraits. You can do this in a couple of ways. Make a rectangular selection around the outside of the photo, just inside from the edge. Feather this at least 20 pixels (the larger the image size, the larger the feather needed, so with a big feather, you get a softer edge). Then invert this selection and fill it with white. With layers, you can fill this selection on a new layer, which will give you more flexibility, since you don't actually change the underlying photo. Experiment with the amount of feathering as this can radically change the effect.

© Jack Reznicki

Jack Reznicki

Commercial Photographer

Many people have asked why I love my Epson printers so much. Is it the rich colors, the control over my imagery, the long-lasting inks, the hot-looking machines? Nope. There's something else I love about Epson photo printers. As a commercial photographer, my imagery may get me the jobs—but the prints from my Epson close the deals. Before Epson prints, I used to make my own C-Prints for my portfolio, or I would hire some of the best C-printers in New York. Compared to either of these, Epson's prints sing a richer tune with a deeper and richer palate of colors. My portfolio books a higher percentage of jobs since I switched to Epson prints. Art Directors just react better to the richer colors and the depth of the prints. Plus, I can shoot something one day and have it in my portfolio the next day—looking exactly the way I want it to look. More often than not, fast turn around and greater ability to get what I want out of an image makes the difference in getting the job.

The first time this happened was a few weeks after I got my first Epson printer. I got a call from an agency looking for baby images for an upcoming campaign. I submitted a portfolio that included two new images. They were close-ups of the faces of an Asian and an African-American baby. Both shots were extreme close-ups; both babies were looking down and they were tightly cropped, cutting into the baby's foreheads. The African-American baby looked great, but the Asian baby just melted on the page. I was able to get the baby's skin to be so light and airy that it was almost translucent. With the African-American baby's delicate features on the opposite page, it was a portfolio spread that made you stop and look—it blew away the Art Director and the client. They decided to do a whole campaign based on that look. I knew I had a lot of good images in my portfolio, but it was those Epson prints of the babies that nailed the job for me. I'm positive of that. The campaign for baby immunization ended up on posters all over New York. How cool is that?

A few months later I was up for another big campaign for a national hotel chain. They were looking at a lot of photographers. A lot. Finally, it became a choice between me and one other photographer. The art buyer called and said it would come down to our black-and-white portfolios. Could I send my black-and-white portfolio for the next-day delivery? I replied that I my black and white portfolio was out. Would two days from now be OK? The art buyer reluctantly said OK, but no later, since they had to make a decision.

Well, not only was my black-and-white portfolio "out", it was also non-existent! I spent the day converting color images into black and white using Photoshop. When I printed the images, not only did they print quickly—they looked smashing! Photos like these would have each taken 2 to 3 hours in a conventional darkroom. Not to mention all the extra effects I could do digitally, like adding grain to make some of the images look a little more "rough." I knew that this client wanted a candid, from-the-hip look. I overnighted the new, still warm, portfolio and kept my fingers crossed. Two weeks later I was on a plane with my assistant getting ready to shoot a great new hotel campaign. Thanks, Epson.

Sometimes it's that last 5% that makes the difference between getting an assignment or not. I know in my heart that without my Epson printers, it's likely I would not have landed these two campaigns. Even now, the prints still blow me away! The control, the ease and speed, the color—these should be more than enough reason to fall in love with these printers. But for me, the "closer" is the jobs I can point to and say: "The Epson prints are what landed these deals for me."

EPSON COMPLETE GUIDE TO DIGITAL PRINTING

Dialing in the Print

Everybody runs into the problem of prints that do not come out of the printer as expected, but frankly, color printing in the traditional darkroom was usually even more frustrating. This is one reason why Ansel Adams never did much color printing and preferred black-and-white. He said that color prints always looked to him like a television slightly out of tune.

When ink jet prints don't look the way you want, they can be corrected fairly easily with a little testing and time, as you'll learn on these pages. With the computer and an ink jet printer, we can make color prints that very much look "in tune."

A lot of people talk about color management in ways that can intimidate the average photographer. Color management is simply anything that controls the process so that the print better matches our creative vision of what that print should look like. Unfortunately, some well-meaning gurus within the digital industry have defined color management in such a narrow way with complicated techniques and technology that it can scare off the photographer who just wants a better print.

High levels of color management are critical to the commercial printing industry because photos in a magazine, brochure or other published piece need to look like the original piece. Some experts promote this level of color management as the cure-all for everyone who wants perfect prints, yet it really isn't for everyone.

Overemphasis on high levels of color management can be distracting to the photographer. Color management at a sophisticated automatic level is built into most operating systems and Epson printers and may be enough for you. The photographer's purpose should be to make a great print, not necessarily match an arbitrary original image which may or may not be accurate to the scene or the photographer's intent. As Ansel Adams always said, the negative (the original) is only the starting point for an expressive print.

Any level of color management is essentially a system to allow different digital devices, from scanners to monitors to printers, to communicate in such a way that color remains fairly consistent on all of them. I say "fairly" consistent, because these devices often deal with color in very different ways. For example, the color you can potentially see on a monitor will always be greater than what is ever possible in a print.

So, I'm going to give you several basic approaches to dealing with color, all of which relate to color management at some level, and save the technical approach to color management until last in this chapter.

I hope this will make photographers relax a bit about color management. I sense from a lot of folks making prints that they feel guilty when they aren't doing "serious" color management, or they try too hard to make prints that "match" the original.

If I can help photographers relax and have fun making prints, rather than getting uptight from pressures to do things "the right way," I know they will enjoy printing more. Printing your own photos should be fun and not a technical test!

The Difference Between the Monitor and the Print

A key to dialing in that great print is understanding that the monitor image and the printed image can never look identical. The reason is similar to why slides and prints from those slides will never look identical. The print is viewed with light reflecting off its surface, while the monitor shows us an image based on transmitted light of glowing red, green, and blue phosphors. Reflected light and transmitted light can never look identical to our eyes. So, we will aim for as close a resemblance as possible, given the two different technologies.

The question arises, however, do we always want to make a print that is exactly like what you see on the screen? This is a valid point to consider. Your monitor displays an image in a very specific environment that probably is unlike the conditions where your prints will be displayed. In addition, a print is a very different experience for the viewer than seeing a photo on a monitor. Often, that print needs a unique treatment that is perfect for it but might not be appropriate for the monitor.

The bottom line is always about the print satisfying you, by itself, in the environment that it is most likely to be viewed.

This is why photographers who sell photos will frequently use a highly corrected and consistent light source (such as daylight-balanced fluorescent lights) to make a final evaluation of their prints. They can't see what their photos will look like in every condition possible, so they limit the condition to a consistent, controllable light source and make prints that look best there. Some even include a disclaimer about the viewing environment and explain the best lighting for their image.

If you are not selling prints, then you need to evaluate your prints in the conditions you expect to display them in. Bright lights vs. dim hallways, daylight vs. incandescent, all can change the way a print looks. You can do this by making a small print for reference (this is faster to print and correct) until you know the right adjustments, then make your big image corrections based on that.

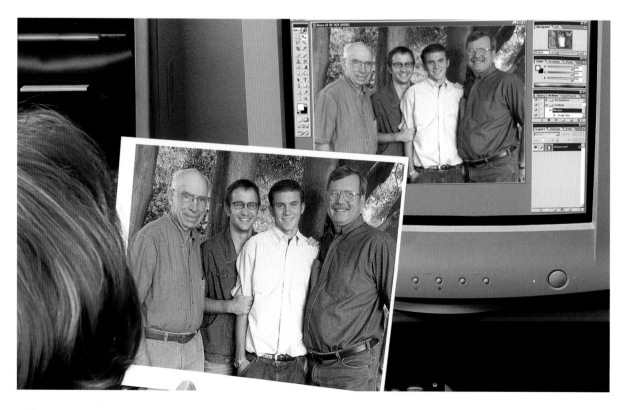

EPSON COMPLETE GUIDE TO DIGITAL PRINTING

Color Space Setting

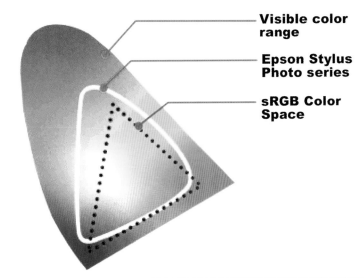

- **Visible color range**
- **Epson Stylus Photo series**
- **sRGB Color Space**

◄ Computers define color in a range of hues called a color space. Digital cameras typically use the sRGB color space. Epson printers can handle more than that, making their P.I.M. system quite effective in getting the most from digital camera images.

Epson PRINT Image Matching

In order to get better photographic-quality prints from digital camera files when printed on Epson Stylus Photo printers, Epson developed a new technology called PRINT Image Matching or P.I.M. It was created as a way of making digital cameras and printers work together to produce photographs that "print truer-to-life than ever before."

Well, most photographers know that real life is never the same as a photo and "true-to-life" is always very subjective. You might think of P.I.M. as an automated color management technology that controls the way digital cameras "talk" to a printer so that they really do work together to optimize the image in the print. What it does is attach information to the digital camera file at the time of image capture, information that can help make a better print, such as camera features used (e.g., flash or white balance), exposure modes and so forth.

What happens is that a digital camera then "remembers" certain information about the photo as it is taken. For example, a close-up shot could be remembered as such so that the printer software would receive instructions on emphasizing detail and sharpness. If the camera has modes, a Portrait mode image might be recognized as needing attention for flesh tones.

Many digital camera manufacturers are including this technology in their cameras to allow them to quickly benefit from Epson printing equipment. EXIF (Exchangeable Image Format) data is an international standard that imbeds camera data into the digital image file and actually is based on the P.I.M. concept. However, P.I.M. actually includes more information for printing in this imbedded data.

This is a somewhat automated way of printing, but it is very useful for those quick snapshots that everyone needs to print at times. Once you start refining your image for printing as described in earlier chapters, this is no longer an important tool. If you do want to use it, check your printer manual for instructions.

Quick Guide to Color Management

Keeping the first thoughts in this chapter in mind, you probably have guessed that I consider printing a craft, not a simple science that guarantees prints matching a monitor if one just follows the "rules" of color management. Color management is an evolving part of computer science. Because of the challenges mentioned above, it may never be perfect in its ability to match monitor and print. But, if you treat photo printing as a craft and not a "computer thing," I think you will find that it is easier to get a handle on this color management stuff.

Here is a quick overview of things to think about when dealing with color printing in the digital darkroom. I'll cover some of these in more detail afterward.

1

Prints will never match the screen exactly. That is like asking a print (reflected material) to exactly match a transparency (translucent material), only it is even more difficult. But once a monitor is calibrated, you gain consistency in making prints look like the monitor.

2

Paper is different. Different papers will result in different color and contrast responses. Plus, the printer driver (software) must be set correctly for the paper.

3

In the traditional darkroom, we always considered it a standard procedure to test and adjust for every different paper or chemical used. Then we wrote down the adjustments and corrections so we could do better later. When shooting a bow and arrow or even a gun at a target, few people complain that the projectile didn't hit the target because the wind was blowing. They adjust for "windage" and we can do the same with the computer.

4

Low-priced color management tools, such as the Monaco OPTIX from Monaco Systems can help.

▲ Remember that your prints will never match the screen exactly. In addition, compare prints on different types of paper to select the best for your needs.

▶ Calibrating your monitor and other parts of the digital darkroom can be very helpful in managing the color of your prints.

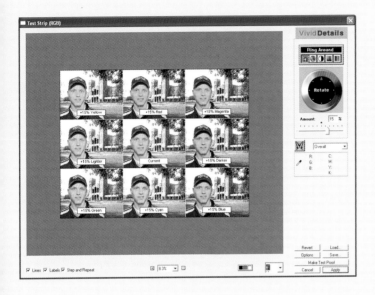

5

Vivid Details Test Strip (www.vividdetails.com) is, to me, the best printing program and a simplified color management tool that is quite photographer friendly. This program lets you print out, literally, a "test strip" where you can see exactly how much you need to adjust your image for the best print on a particular paper. You can save these settings, too (and write them down). What you do is create the best possible image on your screen, open Test Strip, and apply the adjustment (adjusting for windage) and print. This is an excellent solution as you can save multiple adjustments for different papers or other outputs such as slides or negatives.

With Vivid Details Test Strip, you can print out a test print showing variations in color and brightness so you can precisely adjust your image for a better print.

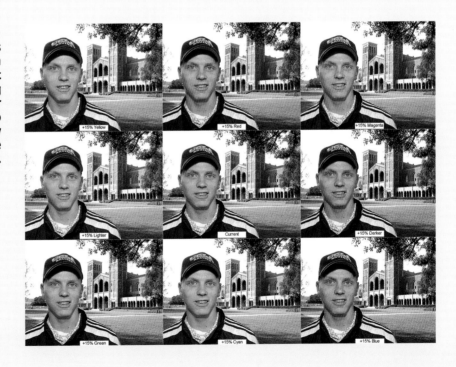

Testing

At any level of printing, you always need to do some sort of testing. You need to know how a printer works, how papers react to the ink, and so forth. Every craft requires you to try something, evaluate it, then make adjustments based on what you have learned.

The simplest form of testing is to make a print and look at it. Is it a good print for you? Never ask if it matches the original unless you are doing work for someone else—that can distract you from your real goal of a satisfying print that stands on its own. Think of it this way: Who (except for some arbitrary-rule-bound photographer) is going to compare your print with the original? All most people care about is the print in front of them.

The trick is making adjustments to correct the print to your liking. It can consume a lot of time, paper, and ink, if you make a print after every little correction. A quicker and easier way to do this is by making a test print. The program, Test Strip, is a superb tool for doing this, but you do need image-processing software that can use Photoshop plug-ins (which includes Photoshop, Photoshop Elements, and more). Test Strip allows you to print out variations of an image onto one page and the variations are labeled as to what the corrections are. This way you can see exactly what different corrections will look like on that particular paper.

If you can't use a plug-in, or you want to try this manually, you can make your own test print. You can do this with any software, but here, I'll give specifics for Photoshop and Photoshop Elements (many other programs use similar techniques). These are the steps:

1 Open a new page in your image-processing software that is 8 x 10 at 250 dpi.

2 Save your photo (that you want to print), then resize it to 2 x 3 inches at 250 dpi. Use the move tool to drag it onto the new page in the upper left. This photo will now appear as a new layer.

3 Duplicate the layer (drag it to the create a new layer icon at the bottom of the layer palette). Drag the photo to the right. If you're doing this as a horizontal, you'll be able to get three images across the top. Combine these image/layers into one layer.

4 Duplicate this layer two more times and drag the layers apart. On a horizontal, you'll now have nine separate and duplicate images with space between them. There is no absolute here—you can actually use fewer, larger photos, but the 2 x 3 inch size is a good one.

5 Flatten the layers.

6 Leave the upper left photo alone and consider it your "control"—the one image that is identical to what you saw on the monitor.

7 Use your rectangular selection tool to select the upper right image. Make an adjustment to it and record your adjustment.

8 Select the next photo down and make another adjustment (maybe brighter by 20 points) and record that too.

9 Then select the photo to the left and try something else. For example, add 10 points of green.

10 Do this for all the small photos. At first, your adjustments may be random. But after some experience, you'll find you make adjustments in more methodical ways because you'll be better able to read your photos for printing.

11 Print this out and look at all the small images. Which one looks best, or at least heads in the right direction towards best?

You may have to make another print with other adjustments to refine the image. You will, however, discover what corrections you need to make in order to get the best color for your image and the paper. You should be able to use this correction to get you started on any photo printed on this particular paper from a specific software program.

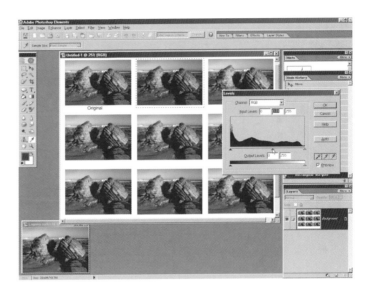

You can make your own test print by creating an image with multiple copies of your photo, then adjusting them individually for a single print.

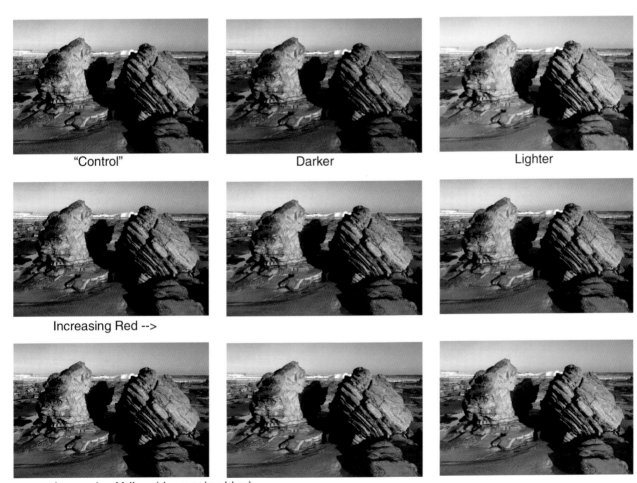

"Control" Darker Lighter

Increasing Red -->

Increasing Yellow (decreasing blue) -->

Adjustments

Armed with the knowledge of what corrections you need, you can make some adjustments to your printing file so that the image prints better. There are several ways to do this and they all result in the same thing, better prints.

Method 1. Adjusting the Image Directly

You can always record the adjustments determined through testing and apply them directly to your photo just before you print. You can also save your adjustments from VividDetails Test Strip and apply them to the photo based on the paper. You need to be cautious when doing this because you are "changing pixels" and you could lose your refined image if you saved over it. You need to keep an unadjusted version of your final image so that, if you print on different paper, for example, you are correcting from a standard image, not one that is changing with every print.

A better technique would be to make a copy of the image on a new layer, then apply the corrections to that layer. You can even make multiple layers and adjust each separately for different papers, then use them as needed.

Method 2. Adjustment Layers

This is another way of using adjustment information from testing for dialing in the print. In this case, you add one or more Adjustment Layers to your photo based on the corrections you need: Levels, Color Balance, Hue/Saturation, etc. Since these layers are just instructions and have no dimension, they can be dragged and dropped onto any open photo in the image-processing software. You might make a special correction file that holds Adjustment Layers to use later.

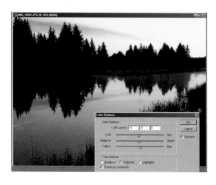

◀ Be cautious when making image adjustments directly to the photo because you are changing actual pixels.

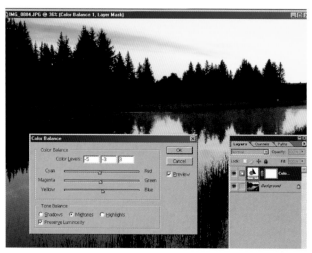

▲ Adjustment layers are always safe because they let you make adjustments without changing pixels.

▶ Since Adjustment Layers are not size specific, you can make a special correction file that holds Adjustment Layers for later use.

Add whatever Adjustment Layers you need to correct the original photo, then make a new print to check that they are correct. Next, resize the photo to 4 x 6 inches at 100 dpi (this is only a viewing file) and do a "Save As." Save this new file in a place you can easily access on your hard drive and give it a name related to the paper you are using. Whenever you print again on this paper, just open this file and drag and drop the Adjustment Layers onto the new photo. You have instantly corrected your photo for printing, yet you have not changed the base image at all.

Method 3. The Printer Driver

Epson has a handy way of making printing adjustments built into the printer drivers. As described earlier, you will find Advanced Settings on the driver (you have to check Custom first). Click on them and you will open a color correction window. This includes sliders that control the brightness/contrast and color settings we covered in earlier chapters. You use these controls, however, to adjust the printer output without affecting the image file itself.

Using the information you gained from testing, set the sliders accordingly. You may need to interpret your test adjustments with the slider scales, which may take a test print or two. But once you have these printer adjustments dialed in, you can save them for future printing with a particular paper.

The Epson driver settings include the self-explanatory Brightness, Contrast, and Saturation controls. The color correction controls, however, only mention Cyan, Magenta, and Yellow, but not all of us think in terms of adding and subtracting just these colors. It will help if you remember that Cyan is always paired with Red, Magenta with Green, and Yellow with Blue, so adding any color will subtract from its opposite part of the pair. Conversely, subtracting any color will add to the corollary color.

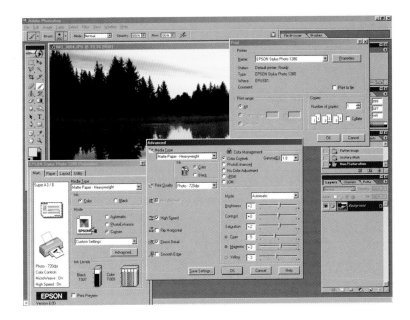

▲ **Print adjustments can also be made directly in the Epson printer driver. These can be saved for later use.**

Advanced Color Management

As I promised, I am going to give an overview of advanced color management and how to use it for those photographers who need this, or just want to understand it better. It can be easier to understand if you keep in mind that color management is always a way of making different digital imaging devices, from scanners to printers, work together to create colors that they all "understand."

Color management tools are like using a detailed map to get to a destination. However, if the destination in the first place is incorrect, no map in the world will make it any better. If I have a great map to a desert hotel and my family hates the desert but loves mountains, I will probably be better off heading toward the mountains in the distance, even if I don't have a map. Color management is no different—if it takes you to a print that meets all the "right" criteria based on the "map", but does not express your intent, then the destination is wrong.

There are several basic concepts you need to understand here: color space, device profiles, and work flow. There are many good references that go into these in far more detail than we can deal with here. I want to give you enough information to understand what these concepts are all about and how they fit into a color management model.

Color Space

Color is a highly variable thing. People can look at the same color and call it different things. The computer has to break down all the colors of the world into digital data that can be later reconstructed into something that looks like those colors. To do that, the computer requires some parameters, so computer engineers have defined color as a space that can be calculated, interpreted, and controlled.

Color space is not a single entity. There are basic, overriding spaces like RGB (red, green, blue—the standard computer space) and CMYK (cyan, magenta, yellow, black—common to the commercial printing process). RGB is a larger color space than CMYK, which means a wider range (or gamut) of color is possible in an RGB device than CMYK output. (Please note that while ink jet printer ink is based on the CMYK set of colors, the printer actually works from RGB data.)

Within that RGB system are even more defined spaces, such as sRGB or Adobe RGB (1998). Each controls color with slight variations in the range of colors and tone. Yet, each is also a standard that is recognized throughout the industry. Once a photo is identified with a specific color space, it is possible (theoretically at least) to display that image on varied, but calibrated, monitors and see the same basic image.

Consistency of colors within the digital realm reaches a higher plateau with consistent color space usage. Changing color spaces can result in a significant shift in colors. For example, going from RGB to CMYK results in a color shift because the CMYK color space is smaller (fewer colors represented). This is why most color purists will, for good reason, stay within the RGB space as much as they can before any change to CMYK for commercial printing. You may want to experiment with different RGB spaces (if your software allows it) to see which works best for you. Many pros prefer Adobe RGB (1998), but do your own tests.

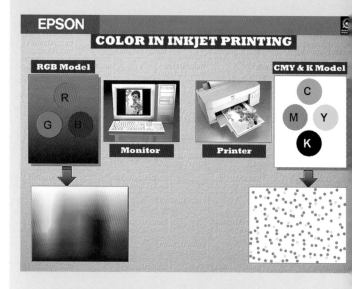

▲ While an ink jet printer uses a CMYK color model, it works directly from the RGB colors of the computer.

Device Profiles

To allow different imaging devices to communicate about color in the same way, we can give them a standard set of instructions—the device profile. A profile is a set of directions the computer gives each device on how to interpret colors. Profiles come from a standard image that is measured for each device. Computer hardware and software manufacturers have standard images that they use. Calibration software will include such images as well.

For example, to profile a scanner, the standard image is scanned so that a profile can be built. The scanned image is measured by calibration/profiling software to create a unique profile that defines how the scanner interprets the colors. To profile a printer, you use that standard image again, print it out, scan it, and build its profile. Advanced users will expand this process by creating profiles for each different paper they use. Epson has standard profiles for its printers and papers on its website. They usually work very well, but you can always create your own profiles.

A monitor profile is built by special software and often a measuring device. Adobe includes a basic monitor calibration program in Photoshop and Photoshop Elements called Adobe Gamma. Companies like Monaco Systems (www.monacosystems.com) and ColorVision (www.colorcal.com) provide both the hardware (measuring device) and software to refine this process. The measuring device and software combine to look at how the monitor displays standard colors, then builds a profile for that monitor.

Once these profiles are built, each device can now control color within a specific range and pass on the color information to the next device. Many manufacturers develop these profiles for their scanners, monitors, and printers. When these profiles are plugged into a program that can use them (such as Photoshop), then potentially, you can have a photo that keeps fairly consistent color from scan to print. Photoshop uses the profiles to translate and adjust color so a better match is developed among all the digital imaging devices. It is very important when working with profiles that your monitor is carefully calibrated and the calibration is checked regularly.

The goal of profiling and defining color spaces is to get a set of gear that talks to each other in a language they all understand.

My experience is that photographers who have closed systems (systems where they control everything from scanning to printing), who like and are willing to spend a bit of time on the science and technology involved with this, have better success with this advanced process coming out "perfectly."

Color management is about consistency from input to output, allowing all devices to communicate, so that they understand each other's use of color. The end result is predictable consistency, which allows artists to focus on the results of their craft and not the mechanics. This consistency requires an understanding of the process and some level of color management control that is regularly applied. Then color management becomes simply another tool for the photographer to use to support his or her vision.

Simplified Color Management
All of this comes together in this way:

1 Calibrate your monitor (Adobe Gamma or monitor profiler).

2 Set your software to work in the appropriate color space. Many people like sRGB for the Web and Adobe RGB 1998 for printing, however, digital cameras are mostly sRGB and you may find you like your prints better from this color space.

3 Either use a profile from your scanner manufacturer or determine one yourself using profiling software. Enter that in your image-processing software.

4 Do the same for your printer and paper.

Now when you print, you should be able to more tightly control your color variations.

Advanced users include profiles for different papers. In Photoshop there is something called "soft proofing" that theoretically can show you on your monitor what a print will look like based on these profiles. I say theoretically, because there are a number of variables involved that can influence the results. I have had folks tell me they can do this perfectly, then I've had other photographers who have been frustrated because the time involved has never given them results they expect from such a process.

© Graham Nash

© Graham Nash

© Graham Nash

Nash Editions

Digital Fine Art Printmakers

In the days when digital imaging was a novelty, rock star **Graham Nash** of Crosby, Stills & Nash fame and his tour manager Mac Holbert were looking for a way to print Nash's digital black and white photographs. When they were introduced to an ink jet printer designed for the pre-press market, they knew they had to have one because they saw the potential for using it to print art. Little did they know at the time that they were co-founding the world's first digital fine art printmaking studio. Today, Nash Editions is arguably the leader in the field, having devoted more than a decade to mastering the fine art digital printing process.

Stunning image quality and permanence are critical to the work of Nash and Holbert. The first ink jet printer they owned gave them quality output but was difficult to keep running properly because it was designed for proofing and not photography. Today they rely on Epson's photo and pro graphics ink jet printers, which deliver image quality and permanence with minimal maintenance.

"The ease of working with the Epson printers is key to us," Holbert says. "It's amazing to be able to walk into the studio in the morning, press a button for three seconds, and within two minutes, the printer is ready to start printing astonishing, photo-quality output."

Even more important than reliability is the wide color gamut, exquisite detail, and longevity that Epson's newest archival printers give Nash and Holbert. "The Epson printers capture exquisite details that you just can't get with traditional techniques," Holbert says. "You know the moment in the darkroom when you watch an image slowly emerge in the developer tray—it's magic. Well, you get the same magic with Epson printers." Furthermore, because the printmakers are often asked to print on alternate substrates, Epson's versatile paper handling is also a big plus for Nash Editions.

Nash and Holbert maintain Epson is the leader in digital photography because they listen and respond to photographers and artists like them.

"Epson didn't ridicule us," Holbert said. "They recognized the capabilities of our business and our pioneering spirit. They were interested in our problems and in pushing the future of printing."

Nash Editions' Web site is www.nasheditions.com.

EPSON COMPLETE GUIDE TO DIGITAL PRINTING

Displaying the Print

Once you've made a nice print, you can do many things with it. In this chapter, I'm going to give you some ideas on displaying photos. There are whole books devoted to this, so I just hope to inspire and encourage you to try out some of them. Have fun with your prints!

When you want a great photo for a framed print on the wall, your Epson printer can create it. But, if all you want to do is put a photo on the refrigerator, that's okay, too. Making a new print is so easy compared to the old days of finding a negative or slide, then going down to the local lab and ordering an enlargement (and waiting days for it to come, then having reprinted when it wasn't right).

Tack-Up Display

The refrigerator is always an honored place for a photo! Kids, parents, and grandparents consider this a great place for photos. There are lots of places that prints can be tacked up, from a dorm room bulletin board to the walls of a workspace cubicle.

Obviously, you can throw any photo up and tack it in place. The print doesn't have to be fancy. However, there are some things you can do to enhance this display and show off your photo and subject (the latter is often most important!). Here are some ideas:

1 Size
Big photos always make an impression, but these display areas don't always have lots of room. 5 x 7 inch sizes can be ideal—you can even print two of these on a single page.

2 Contrast
Because these areas don't always have the best light and there is a lot of visual competition, photos often need a boost in contrast and color saturation to make them standout.

3 Borders
Borders, especially simple lines, can add a great touch to photos used in tacked-up displays.

4 Words
Try adding some simple text, maybe the names of the people in the photo or a location, either in a corner of the photo or below it.

◀ **Because you can make prints easily with your printer, you are free to create them for everything from a formal wall display to the refrigerator.**

◀ **Sometimes simple, direct frames are the most effective way of displaying your images.**

Simple Frames

The next level of display is to get your prints into a frame of some sort. Framing sets off the print and protects it from the environment. It gives an impression of importance to the photo.

I think that some photographers don't frame their photos because it just seems like too much trouble, finding the right size frame, matting and mounting the photo, and so forth. While a matted photo can be a stunning use of your images, this is not a necessity for having a nice print display on the wall. Try these simple ideas:

1 **Quick frames**

At craft or art-supply stores, you can usually find an assortment of frames that you simply pop open, put your photo in and then snap the glass back in place. Use your image-processing software to make an exact-sized print (including any border or edge treatments) to fit the frame size. The Original Format Frame by MCS Industries is one that I've found very useful because you can buy it in an 8 ½ x 11 inch size that allows you to use a print directly from the printer without doing any trimming. I like to use these frames with prints that do not print to the edge so I can add an edge-treatment or have a nice border that sets them off.

2 **Fome-Cor™**

Made of a rigid foam between two sheets of heavy paper, Fome-Cor™ is that ever-adaptable art supply material. It is a very light, yet strong, display material that comes in a variety of thicknesses. A very easy display can be made by mounting your photo to a piece of Fome-Cor™ then cutting it out so that you have a rigid, borderless photo that can be attached to a wall (this is a common photo display for tradeshows). You can use spray-on adhesives (use them outside or in a well-ventilated area and protect the surrounding areas from spray drift) or special mounting sheets made for the purpose. Many copy stores will do this for a small fee.

3 **Poster frames**

Craft and art-supply stores also often have inexpensive poster frames that can be used for quick framing of prints. These frames use clear-plastic rather than glass over the image, then have strips of flexible molding that cover the edges and hold the plastic, print and backing together. These can be an inexpensive, easy-to-use solution for larger prints. You can cut them to fit a specific size by using a very sharp knife (cut through the plastic slowly, using moderate pressure over multiple passes of the blade, so you don't crack the plastic).

Albums

Photo albums are great. We all love to take a look at photos from over the years. But they can be a chore to put together, so many old prints sit in shoeboxes at the back of a closet.

Rather than trying to put every photo into an album, try making theme albums of larger prints. The whole phenomenon of scrapbooking takes this idea to new and creative heights. Check out any of the excellent scrapbooking books on the market for ideas. Craft supply stores will even have whole sections devoted to this.

Themes are a great way of using albums. Print a set of images from a trip or an event, such as a birthday or other party, and put them all in one album. Use extra pages for text to explain what the photos are all about. Don't try to fill the album—just remove unneeded pages so that the album seems complete.

Or, you may simply want to put your photos together in a nice album without the work of fancy scrapbooking. How ever you use albums, look for acid-free paper and mounting sheets. The plastic pages should be labeled as "archival" to assure they will protect the photos and won't cause any deterioration.

▶ **Of course, you'll want prints for an album of family memories and history.**

© Jan Press Photomedia, Livingston, NJ

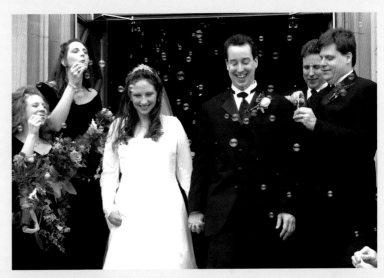
© Jan Press Photomedia, Livingston, NJ

© Jan Press Photomedia, Livingston, NJ

Advanced Mounting and Framing

You can customize your print display with all sorts of mounting and framing techniques. You can have these done for you at a framing shop, or do it yourself from materials purchased at craft and art-supply stores. This can be quite involved, with a lot of special tools and techniques. That's beyond the scope of this book, but here are some ideas to keep in mind while looking to custom display your prints:

1 **Match your frame to the display area**

Look for frames that fit and complement or supplement the setting. A room with antiques begs for a frame and matte with detail and a feeling of age, so a silver metal frame is likely to look out of place. On the other hand, a rough wood frame won't look at home in a modern office with fabric and metal details.

2 **Black frames are always safe**

Some people might consider black frames boring, but actually that's why they are perfect for photos. They don't compete with the image, nor will they conflict with any colors. Black usually makes colors look better. You can never go wrong with a simple black frame.

3 **Make your print the star**

Sometimes art supply and framing stores will try to sell you an elaborate frame and matte. You want your photo to be the center of attention, not the frame. Be sure the detail and color of a frame and accompanying matte make your photo the star.

4 **Use size to set off your image**

Sometimes a big photo in a big frame is the most dramatic way to use your photo. In this case, you often want a minimal matte treatment because the photo will actually look bigger if it is pushing the edges of the frame. Another effective display technique is to place a small

▲ **Frames come in so many styles. You can often find one that fits the setting and tone of your display space.**

photo in a larger frame, matted in white or a neutral tone. You might use a 5 x 7 inch print in a 16 x 20 frame, for example.

5 **Choose matte colors carefully**

Over the years, I have had the privilege of judging many photo contests. One thing that I have seen as a consistent problem in display contests is a matte color that takes over the photo. An example of this would be a nice photo of pink flowers surrounded by a strong pink matte. I know that a lot of interior designers like such an approach because it makes for bold color in a room. However, it destroys the photo. It takes the eye away from the colors of the image rather than complementing them. You can pick up colors from the print in the matte, but use colors that do not compete with the dominant subject color. Neutral tones can be very effective ways of working with a matte, or use neutral colors with a hint of image colors.

6 **Use acid-free mounting papers and tapes**

Acids in cheap papers and mounting tapes or glues can ruin a print in a few years. Keep your framed image looking good by using acid free materials.

▶ Simple matte colors can range from white to a soft color based on a subtle color in the photo. These are good choices to complement the photograph.

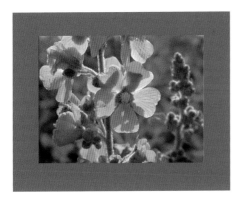

▲ This matte dominates the photograph. Be careful to choose colors that will make your print the "star."

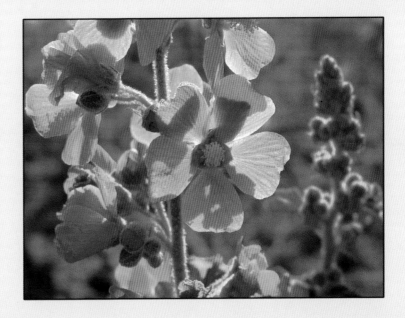

There are many options for matting a photo. All can be effective in the right location. Photos usually look best when the matte is slightly wider at the bottom.

If the borders on the matte are too thin, (top right) a borderless print, without a matte, would probably be a better choice.

Prints look their best in light that favors them.

Where to Display

Once you've put together a nice presentation of your print, consider how you can best display it. A little planning can dramatically enhance the effect.

Consider your wall space and picture size. A large photo in a small area will often appear cramped, while a small photo in a very big space will tend to look lost. If you can't make big prints for the latter situation, try putting groups of photos in the area. Groupings can be an excellent use of a large area. Theme groupings can add impact to the images, such as a group of family photos or a selection of flowers.

Use whatever size frames work for you, but you'll find it easier to deal with the images both in terms of frames and groupings, if you limit the sizes to a few in any given display area. A hodgepodge of frames might be okay for grandma's stairwell display of the grandkids, but it tends to draw attention to the frames and away from the photos.

Contrast a large photo with several small ones. Or try a group of moderate-sized images in a formal pattern. Photos can be arranged formally (all lined up along at least one edge) or informally (arranged without any edges lining up). It always looks odd to see one photo out of line in a formal arrangement, or one photo lined up with another in what should be an informal grouping. Be consistent so that the group is either informal or formal.

Photos can be chosen to dominate a space or blend in with the décor. The subject and composition of the photo, the size of the print, as well as the type of frame will heavily influence how dominant a photo is on the wall.

Lighting

Your prints will look their best with the right lighting. There are a variety of things you can consider about the lighting conditions to make your prints look a little better.

In areas with a lot of glare, use glare-reducing glass. Some people will use this type of glass all the time, but it can reduce the contrast of a print. This reduces the full impact of Epson photo blacks, which

are so rich and deep. Matte-finish papers can be another good way of dealing with glare.

Recognize that direct sun as well as bright fluorescent lights can cause fading in prints. Be sure prints displayed under these conditions are made with archival techniques (described in more detail in Chapter 14 on long-lived prints). You can also use special UV-filtering glass to help.

If you can't control the light in an area, you may need to control the print. A dark print may have a beautiful mood, but it is likely to just look muddy in a dark hallway. Choose a brighter image for such a location or make the print brighter.

Dedicated light for prints can be a great idea for areas that include prints as an important part of the décor and when you have special prints that deserve the best light. Avoid fluorescent lights in these conditions. Standard fluorescents never make any photo look its best. If you must have fluorescent lights, try some of the daylight-balanced models.

Avoid glare-producing lights. This is highly dependent on the height of the lights and is one reason why many people use top lighting that carefully illuminates the photo (or group of photos).

Track lighting is ideal for illuminating photos. The light can be directed, yet is above the photos so no glare appears. Low lights can be a problem, because they often reflect in the prints or glass over them. Floor-mounted lights can give a dramatic effect, but they can also give a weird feeling to the frames, because we are not used to this type of low-angled light. Incandescent lights work well, including the soft halogen types often used in track lights. Keep the lights a little away from the wall so the photo isn't lit directly from the top, but not so far away that you start seeing the lights reflected in the glass.

© John Shaw

© John Shaw

John Shaw

Nature Photographer

Considered to be one of the modern masters of nature photography, John Shaw's work has appeared in everything from *American Photographer* to *National Geographic* to *Smithsonian*. He is also known as a lecturer, a leader of photographic safaris, and an author. His book entitled *The Nature Photographer's Complete Guide to Professional Field Techniques* is considered a classic.

Shaw embraces digital technology in his work, and teaches seminars on the digital darkroom, using his prints to illustrate what can be done at home with a computer, Photoshop, and an Epson printer. He uses some of the latest Epson models, including the wide-format printers, to make prints of his images that have been scanned from 35mm and 6 x 17 film. As for the papers he prefers to use, he likes the look of Epson's Premium Luster, but likes canvas and fine art papers as well.

Shaw's business has been strongly affected by his use of Epson printers. He says that before Epson he intentionally stayed away from selling prints. "I was always disappointed with prints from a lab," he says, "no matter how 'professional' the lab billed itself." Now Shaw can produce prints exactly the way he wants them to look. In addition, he can do this on his own timeframe—no back and forth to a lab. Consequently, selling prints has become a great addition to his stock photo business.

The biggest secret to getting the most from the printers? "Calibrate, calibrate, calibrate with a monitor calibration tool." With this tip he says he can make prints of different sizes or different papers, and they will all match in color. "Try doing that in an analog darkroom!"

With the introduction of Epson's latest printers, he feels the traditional darkroom is, for all practical purposes, dead in the water. "Combine these printers with powerful but affordable computers running Photoshop, and suddenly pro lab quality is available to anyone."

Shaw's Web site is at www.johnshawphoto.com.

© John Shaw

𝓛atvia
the green heart of the Baltic States

an exhibition of photographs
by
Niall Benvie

MONTROSE MUSEUM, PANMURE PLACE, 13TH JULY - 9TH AUGUST 2002

Printing Projects

Making a great print can be very satisfying. In addition, all the techniques you learn in producing a print you like can be applied to lots of different printing projects that include photos in interesting ways. This can range from a simple "For Sale" poster to an elaborate brochure. Being able to use photos in many different ways, both for pleasure and business, is a real joy for photographers.

I am going to give you a variety of ideas with some tips on how you might do them. Try them out as they interest you. Experiment with different applications of these ideas. For example, a flyer featuring your photos could show off your images to a magazine. You could use exactly the same technique to feature photos of collectibles, antiques, jewelry, and more. The neat thing about the computer is that you can experiment without any real cost. If you don't like something, you delete it. And if you do like it, you can print as many copies as you want!

Postcards

Postcards are such a wonderful way of using your photos and sharing them with others. Postcards are so quick and easy that you can use them for many things: birthday greetings, birth announcements, thank you notes, business promotions, or keeping in touch. Here are a few ideas:

1 Make them a standard size that allow you to either print on small sheets (such as, 4 x 6 inches) or four on an 8 1/2 x 11 inch page so you can print more efficiently. All Epson printers will handle 4 x 6 inch paper directly, which do individual cards as you need them.

2 Fill the card with the photo. Use borderless settings with printers that offer them. You can also buy special postcard papers that allow you to print past perforations that you remove to get a borderless image on printers without borderless capabilities.

3 Use text on or near the photo. Postcards are often put up on refrigerators, bulletin boards, and so on. If the reason for the card is not included on its face (in text), it can lose some of its effect. For business purposes, always include your name, phone number, and email on the photo side of the card. You want your recipient to be able to associate you and your business with the photo. Whatever the purpose of the card, keep the text simple (e.g., Happy Birthday, Sammi or ACS Natural Designs), bold and in an easy-to-read typeface and size. Use colors that complement the photo (white or black are safe).

4 Create a special design for the back. You can design it like a standard postcard with information about the photo plus room for the address and a message, or you can be as creative as you like—you just need a space for the address and postage. Make sure that it fits the format of the photo and paper. You can get paper that can be printed on both sides: one side is the photo, the other the text. Personally, I like using adhesive printing paper, because you can peel it off the backing then stick it to your photo. It gives the photo a little more substance as a postcard.

Letterhead

A business friend of mine incorporates a small photo in his letterhead and he changes it every time he sends me a letter. This is a very impressive, yet subtle, way of reminding people what he is doing in his business.

I started adding a single photo to my business letters a few years ago. It really dresses them up. Of course, photography is my business, but it is fun to share people, places, and things that I have photographed. In addition, I made up a simple letterhead that incorporates a photo.

Most word-processing programs can add photos (see below). Many low-end photo and design programs actually include letterhead designs that you can modify with your own work. The advantage of doing a letterhead or adding a photo to a page in a word-processing program is that you can save a master that you can use for typing the letter itself. You can, however, print out letterheads designed in other programs that you can run through your printer again later to print the letter itself.

You should reduce the size of your photo so it is the size used on the page at the needed image printing resolution, such as, 2 x 3 at 300 dpi. When working in programs like Microsoft Word, add your photo into a text frame, don't add the photo directly to the page. By inserting a text frame first, then inserting a photo into it, you can more easily move and position the photo on the page.

Mailing Labels

Mailing and address labels are so easy to do today that I am sometimes surprised that I don't see more of them used with photos. You can get labels of almost any size, plus many photo and design software programs include specific templates for the exact label you buy. Not all of the labels use photo-quality paper (though many do) but I'm not sure that's really all that important. Having a nice photo on a label is so unique that it will stand out no matter what label paper is used.

There is not a lot involved with labels except that the image and text (such as your return address) have to fit. I like to print a quick check print using cheap paper to be sure the labels are lined up properly for the label paper. Hold it in front of a piece of label paper then up in front of a light to see if it all fits.

You should think a little differently about choosing a photo for a label than if you were making a big print. Photos on labels are small and they need to be understandable to work right. Many great photos don't look that great when reduced to fit the small size. Try to pick photos of single subjects without a lot of small detail. You will need to resize your photo in an image-processing program so that it fits this size at a printing resolution (such as, 1 x 2 inches at 300 dpi). If you use a large image size, say an 8 x 10 at 300 dpi, without reducing it, you will end up with a very large file that could slow down your computer and even make it crash. Do a Save As once you've resized your photo so your bigger file is protected and you have a small file just for this purpose.

Photo Montage

When you put several photos on a single printed page, you gain some wonderful opportunities to make a very special print. One way of doing this is to create a montage. This technique layers photos on and around each other so that the group of photos becomes one unit. It can be a great way of expressing something about a subject that cannot be done in a single image. Think about starting with a portrait of a child, then adding images of him or her playing soccer. Or how about a portrait of two senior members of your family along with photos of them through their many years.

The easiest way to make a successful montage is to plan it around a single strong photo. There are certainly other possibilities, but when you use a single strong photo as the largest image, it becomes

a foundation for the montage as well as an anchor for the viewer's eye. Then build the image with smaller photos that interrelate with the big one. Montages are usually best made with either a design program or an image-processing program with layers, as either type of software allows you to move the individual elements around by simply clicking and dragging the photo. You will want to do a lot of moving of the montage pieces around until it looks just right.

Two opposite, but very effective, refinements to a montage are drop shadows and blended edges. Drop shadows added to the individual photos really make them stand out and give the overall image some interesting depth. Play around with the softness and opacity of the drop shadows. Blended edges allow you to link and combine photos in some very striking ways. Create a soft edge (the technique is described in the border section of chapter 8) to start and try using either a soft-edge eraser, or a layer mask, to better blend photos.

Grand Tetons National Park

▲ **By combining several photos together in a single montage, you can make a very special print.**

Printing Multiple Photos on a Page

There are many situations where you want or need to print more than one picture on a single sheet of paper. You may want to print out a whole group of 4 x 6 inch photos onto sheets of 8 ½ x 11 inch pages, or maybe you want a "picture package" that includes several different sizes on a page. Either way, it can be more efficient and cost effective to maximize the use of the paper.

You have a number of options for doing this. Adobe Photoshop and Photoshop Elements include something called "Picture Package" in the File menu under Automate or Print Layouts. You can select a whole series of multiple-picture-on-a-page layouts that can be printed with duplicates of the same photo or different images. The program does the processing of the images for the layout automatically. A number of other image-processing programs do this as well, including Microsoft Picture It! (www.pictureit.com).

In addition, there are some stand-alone programs that make multi-picture printing very efficient and don't require you to open an image-processing program. These include ArcSoft Photo Printer (www.arcsoft.com) and ACDSystems FotoSlate (www.acdsystems.com).

▲ Flyers that combine text and photos often make a strong statement. They can easily printed on an Epson printer.

Photo Flyer

A flyer is like a montage because it has multiple photos on a page. You could certainly build a montage for a flyer. The difference is in the use of text and purpose. A flyer is something that has a strong message, often business related, so the photos and text must be carefully chosen so that they work to support it.

Flyers are often weakened by poor use of text and by the use of too many small photos. You may want to try out some of the design templates offered in many low-end image-processing programs and design software. Use them as a starting place and modify to your needs. Check out the design books by Robin Williams for some excellent ideas for building a flyer and other designed projects.

◄ Printing multiple pictures on a page is a more efficient use of your printer and your printing paper.

Here are some tips to make your flyer work better for you:

1 Use clean, easily read text

No matter how great a message you have, if the reader finds your text hard to deal with and won't read it, you've wasted a flyer. The simple typefaces such as Helvetica, Arial, Times Roman, Garamond, and Eras are not exciting but are very readable. Anyway, your photos should be the center of attention for the piece, not a fancy typeface. You can use fancier typefaces for short text like a headline.

2 Keep typefaces to a minimum

Too often, I think, because there are so many typeface choices in the font menu, flyers become a mishmash of type that is confusing to the reader.

3 Pick a key photo to be your star

Make one photo a focal point by keeping it large and dominant on the page. This gets far more attention from the reader than many small photos.

4 Use small photos to support the big one

Small photos add context and depth to your message, and they visually support the big photo as well. They make it more dominant from the contrast.

5 Pay attention to details

It is easy to look at the bold, attractive photos on your page and miss important details. It is a good idea to print out the page for this reason—I have often missed things on the computer screen that looked obvious when printed out. Watch out for missing text or pieces of text—this happens when you move things around on the page and the elements interact with each other. Be sure photos line up when they are supposed to. If two photos look like they are in a row, but one edge is a little off, it makes the design look sloppy.

6 Use edge borders

A thin black line around photos can really help set them off on the page.

▲ When used with photos, text needs to be easy to read and carefully placed, whether on a straight print or in a brochure.

Newsletters

Family newsletters with photos have become very popular in recent years, in part due to the computer and ink jet printer. They are now used more often, not just at Christmas. In addition, many businesses have found newsletters to be a great way to keep in touch with clients and customers.

Because newsletters are fairly easy to produce, they too often look like they have been thrown together with little thought to the design and use of text and photos. Many design and low-end image-processing programs include newsletter templates that can be excellent starting places (and can be worth the price of the software alone). Broderbund even has a PrintShop program just on Newsletters and Brochures. The Robin Williams books can also be most helpful.

Many of the ideas in the flyer section are just as important for making a good newsletter. A clean, readable typeface is absolutely vital for the main text and should stay the same throughout the newsletter. Any time you change the text font, be sure it is for a very specific reason, such as highlighting a special achievement of someone.

Bold, simple headlines are also important so your reader can quickly understand the newsletter and so that it looks inviting.

Use a few photos boldly and don't try to cram too many images on a page. If they look cramped and fight each other for space, there are too many photos. Look at the front page of a newspaper. Photos are chosen carefully for how they support the stories and gain reader attention. You do want people to read your carefully prepared newsletter. One way to do that is to make it compelling and inviting through the use of selected, but intriguing or engaging photos. Be bold! Feature your photos!

Newsletters have a very specific look. Part of this is a very structured appearance, which includes the location of the title and logo, how the columns and photos line up, etc. Paying attention to these details can make the newsletter more inviting to your reader. And be sure your name, address, and email are included somewhere (in a small box near the end is always good.) It also helps to include some reference in the logo area, so your readers have a reason to remember you.

◀ **Newsletters, a great use of your printer and photos, can communicate to many audiences.**

© Joseph R. Meehan

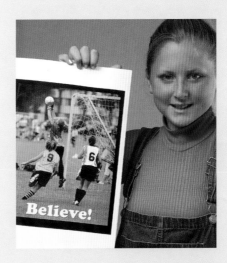

© Joseph R. Meehan

Posters

With the larger Epson printers, both desktop and graphics ink jets, you can make some wonderful posters that can be used for everything from a dorm room to church events to business promotion. This can be a great way to promote organizations you support and use your photography as well.

Putting together a poster is like making a postcard or flyer, but much bigger. All of the ideas presented in those sections can help with posters. Be sure you use a heavy-enough paper for the use (a church poster in a hallway is going to be more stressed than one in an office cubicle).

◀ **Posters made with larger Epson printers are often most dramatic if the text is simple and bold.**

Greeting Cards

Whether it's a grandmother who gets a birthday card with a photo of her grandson saying "Happy Birthday, Grandma," the family friend who gets a thank-you card showing the sender with the gift, or the client who gets a "keep in touch" card with pretty landscape photos personally shot by the sender, each is surprised and pleased to get a unique, personal card that says the sender really cares.

You can get special card papers (and envelopes) that are prescored for borderless cards and for easier folding. They usually include instructions on how to make a card that has text on the inside as well as photos on the outside. Sizing can be a little tricky, so make prints on inexpensive paper first, fold them up to see that everything fits properly. Then hold them up against the good paper to see if everything is printing the way you want. Remember that standard glossy photo papers do not always fold well. You may find the matte finish papers work better for you.

Many inexpensive image-processing programs include templates for making cards. If you do a lot of cards, they can be well worth their low cost, even if you do higher-end imaging work in Photoshop. Epson has instructions on making greeting cards on their Web site in the Print Lab and Craft Projects section.

Brochures

A brochure can be an excellent way to use your photos in a community organization or a business. The key is planning. I find it very helpful to take a sheet of paper, fold it into the brochure form, and doodle notes and pictures on it. Or, find a commercial brochure you like and use this as inspiration.

I will even print out small photos that I can cut out and tape into place to get an idea of how the photos might look. Admittedly you can do this in the computer, however, a brochure is made to be seen in the hand, not splayed out on a computer monitor, so I want to get a feel for this.

A brochure always has a cover. You need to pay special attention to it, using bold but limited type and a strong photo to get your viewer's interest. Give them a reason to pick up the brochure and open it.

Then you need to look at each piece of the brochure as it opens. Be careful that you don't cram too much text or two many photos into it. That can make it very uninviting, making your reader stop reading and put it down, something that you don't want. Use the tips from the flyer and newsletter sections above about using photos and text. Don't be afraid to use some color for attention, but restrain your use of color to only a limited selection of hues.

Look for brochure templates in many design programs.

Booklets

I have done booklets with many photos as programs and yearbooks for my kids' sports teams, as well as church directories. A full-color booklet can be a very dramatic and effective way of showing off your subject, such as the kids on a team, and is usually received with pleasant surprise even in today's world of computers and high-quality ink jet printers. I once did a 36-page program/yearbook for my son's baseball team and printed all 150 copies on my ink jet printers! Such booklets will definitely take some time to print, but I have found them worth doing because they are satisfying for everyone involved.

Here are some tips:

1 Choose the right paper
A thicker, high white ink jet paper is ideal. This lets you print on both sides and you'll have minimal bleedthrough (photos or text that show through to the other side). I've found that you need a minimum of a thick 24 pound paper or a regular 30-38 pound paper to work.

2 Design a graphic cover
Do something simple with a big title and a big photo. Again, there are many templates available for this in software programs. Avoid having too many photos and too much text.

3 Create a real book
While you might not need a table of contents, it helps to make up one for planning purposes. This will help you include things like an introduction, "chapters" (on specific topics), and so forth.

4 Use a simple font for the text
This makes it inviting and readable.

5 Use photos for contrast
Try some big photos on pages as well as pages with many small pictures. This can make the booklet more interesting.

6 Use moderate photo-quality settings
Unless you are going for a photo book quality and are using the highest quality paper (which you can do), use the Fine 360 dpi or Photo 720 dpi settings (test them with your paper to see which looks better—you can also try some different paper settings in the driver as well). This will give excellent quality while offering faster printing speeds.

Black-and-White and Panoramic Prints

Photography actually got started with black-and-white outdoor images and the tradition of black-and-white landscape work is especially rich. It includes the Western frontier photography of Timothy O'Sullivan and William Henry Jackson, through the grandeur of Ansel Adams, to John Sexton's glowing black-and-whites of today. It was actually the black-and-white prints of Jackson over a hundred years ago that helped influence Congress to set aside the Yellowstone area as the first national park.

A fine black-and-white print can be a wonderful thing to behold, often much better than anything you will see printed in a book or magazine. Yet, getting a good black-and-white print wasn't always easy. The local minilab rarely gave top black-and-white results and building a darkroom wasn't an option for most people.

Luckily, ink jet printers are capable of making superb black-and-white images. In addition, the computer lets us do things to a black-and-white image with more control and precision than you could do in the traditional darkroom.

Getting to Black and White

Most black-and-white photography has been shot with black-and-white film. This is still a viable and challenging way to photograph. Many excellent black-and-white films are available, including the superb "chromogenic" films such as Ilford's XP-2 and Kodak Black & White +400. These are color technology-based films that yield a black-and-white negative, but can be processed at any color minilab in the standard C-41 color print film developers (which makes them very easy to use, even if you don't have a darkroom).

If you shoot black-and-white negatives, you can scan them directly with any film scanner or flatbed with appropriate transparency adapter and enough resolution. You have to tell the scanner you are scanning a negative. If your scanner doesn't let you do a black-and-white negative, just scan it as a color negative and remove the color in your image-processing program.

You can also shoot black-and-white directly with many digital cameras. These give you an image file without color and you can see the black-and-white effect on your LCD monitor.

Many photographers are discovering that the computer provides a new option—shoot in color, then convert to black-and-white. These new-thinking photographers gain some unique advantages that are unavailable when the original image is captured in black-and-white. These advantages are related to filter effects, how different colored filters change the tonality of a scene as it is captured from real-world color to black-and-white.

You can actually make superior black-and-white prints by shooting in color first!

Here's why you might want to shoot color for black-and-white prints:

1 **Filtration after the fact**

Filters strongly affect contrast in black-and-white photography. Dramatic skies are created using red filters, bright foliage is enhanced with green filters, and so on. You can always filter the color image in the computer, after shooting, to translate the scene into these preferred black-and-white tones.

2 **Interactive filtration**

Suppose you are new to black-and-white photography and don't totally understand filters and their effects. With the digital darkroom, you can try different filter effects on the same scene and instantly see how they change it.

3 **Totally variable filtration**

No matter how many filters you take with you into the field, you still have a limited set of filter colors to use in order to control the tones of the scene. In the computer, you can fine-tune the filter colors to very subtly adjust grays in the black-and-white image.

4 **Multiple, yet separate filtration**

Think of a scene with red flowers against green foliage in a landscape that includes beautiful clouds in a blue sky. A red filter will make the sky darkly dramatic, setting off the clouds, but maybe you don't like its effect on the plants because the red flowers will be light against dark foliage. You could use a green filter to make the leaves light and the flowers dark, but the sky will not be so dramatic. In the computer, you can select the flowers and foliage part of the photo and apply a green filter, then select the sky and apply a red filter effect.

Translating Color into Black and White

There are a variety of ways of translating color images into black-and-white in the digital darkroom: the computer, an image-processing program, and the printer. I am going to explain seven ways of making the color translation to black-and-white tones.

1 **nik Color Efex**

This Photoshop-type plug-in offers a superb black-and-white conversion tool (most programs, not just Photoshop, can use Photoshop-type plug-ins). It is available in the Color Efex Pro! complete collection as well as the Color Efex Pro! Design Bundle (www.nikmultimedia.com). What makes this little program so effective is that you control the filtration of the scene with a simple slider that goes across a spectrum of colors. As you adjust the slider, you can watch how the colors affect the gray tones in the image. It is like having an infinite set of color filters for black-and-white. In addition, you can control the strength and brightness of the effect as well—try that with a traditional black-and-white filter!

2 **Color channels**

Photoshop and other advanced programs include the ability to look at and separate the individual color channels that make up an image (usually RGB—red, green, and blue). In effect, this gives you three very different conversions to black-and-white, as if you shot the scene separately with red, green and blue filters. Once you find a color channel that looks good to you, you can delete the others or change the photo into a Grayscale image, which gets rid of all color information. The Split Channels command will separate the color photo into three separate black-and-white images based on the channels.

RGB color

Green channel

Grayscale

Many imaging programs have a command that will break a color image into black-and-white images based on its separate color channels.

Each channel creates a black-and-white conversion with a distinctly different look.

Red channel

Blue channel

3 Channel mixer

Photoshop has an interesting tool in the Image/Adjust menu called the Channel Mixer. If you open this and set it to black-and-white, you can adjust the tonalities of the black-and-white conversion by playing with the red, green, and blue channel sliders. More of any channel will make colors related to that channel lighter, and opposite colors on the color wheel, darker (e.g., more of red will make reds lighter and blues darker). If the numbers for each channel add up to 100, the photo stays at about the same brightness as the original color image. If they go higher, the black-and-white version gets lighter; if lower, it gets darker.

4 Selections

You can always make a selection to isolate part of the photo before making your black-and-white translation. This allows you to selectively change colors to gray tones, as if you shot part of the scene with one color filter and another part of the scene with an entirely different filter.

◀ **By selecting parts of a photo, you can change them to black-and-white separately and differently. The top photo is a straight grayscale conversion. The lower photo favored red for the conversion in the top and green in the bottom of the photo.**

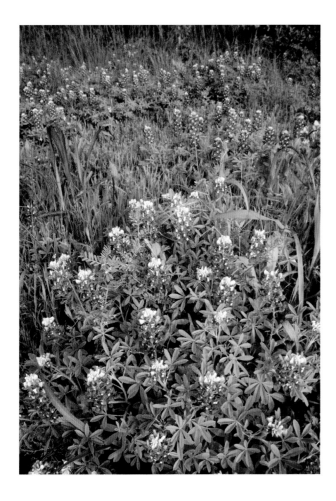

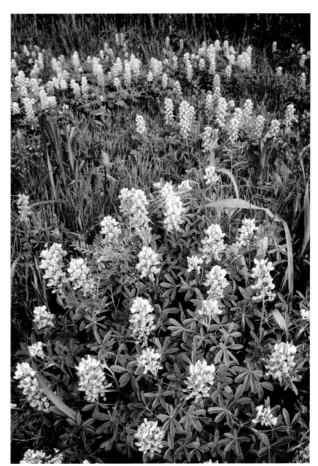

5 Grayscale or Desaturate

Many image-processing programs will let you turn
a color image into black-and-white by changing
the color mode to Grayscale (which discards all
color information), or by using a Desaturate
command (which gives a black-and-white image
in color). These are quick and easy ways of dealing
with images that don't need a lot of adjustment,
but on many photos, they may tend to make the
image look too gray without enough contrast.

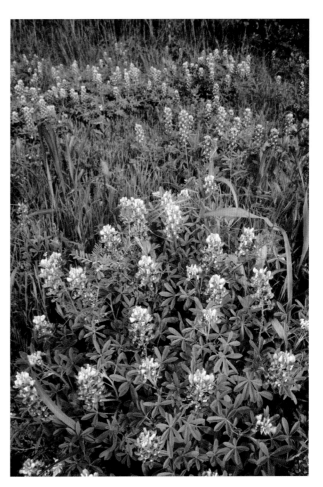

▶

**Grayscale or Desaturate
commands have limited
ability to adjust the tones
in a black-and-white
conversion (bottom right).
Channel Mixer and nik
Color Efex offer greater
control in how colors
change to black-and-white
tones (top right).**

6 Grayscale vs. RGB color for black-and-white

A Grayscale image is a photo without color except black, white, and gray. It is a smaller file than a color image. All of the above techniques can be converted to Grayscale if needed. Having a black-and-white photo in RGB color allows you to color or tone the image with a sepia or cool selenium tone, or other color toner effect.

7 Hue changes

If your program doesn't accept plug-ins and it won't separate channels, you can still make some changes to a photo that will affect the black-and-white tonalities. Use the Hue/Saturation control and change the hues (colors) of the photo before you make the Desaturate or Grayscale change. Change the colors and you alter the resulting grays.

Black-and-White Adjustments

Once you have a black-and-white image, you can continue to make adjustments in your image-processing program. Try increasing the contrast to make the photo more dramatic. You could use Brightness/Contrast for overall effects, but Levels and Curves offer more control. With Levels, bring the left (black) slider to the right and move the other sliders left to increase contrast. With Curves, make the line steeper for more contrast.

You can also dodge (lighten) and burn (darken) parts of the photo as well as darken all the edges (as described in Chapter 8), clone, and so forth, just as you would with any photo.

Black-and-White Image Printing

Black-and-white prints can be beautiful from an ink jet printer. However, they are sometimes hard to print as a "pure" black-and-white photo with four- and six-color printers. Frequently, there will be a slight color tone, even when printing from a grayscale image without color.

Yet, you will get your best results printing black-and-white images as if they were full-color in the ink jet, because that is the only way an ink jet printer will render the full range of gray tonalities. Ansel Adams processed his photos with a toner (sepia for a warm look or selenium for a cool look). So, giving your images tones to make them print better on your printer is really a time-honored artistic technique.

If you absolutely must have only black-and-white tones, there are several options. Epson's seven-color photo printers add a gray ink (which Epson calls "light black") to the normal six colors. It allows these printers to gain more neutral black, whites, and grays while maintaining the range of tones.

You can also check out some specialized black-and-white inks (that replace the colored inks in Epson printers) available from InkJet Mall (www.inkjetmall.com) and Luminos (www.lumijet.com). I've seen some stunning black-and-white prints from these inks, but you do need to dedicate a printer to black-and-white printing in order to use them. This is because you risk clogging the printer head if you switch back and forth from black-and-white printing to color. Note that Epson's printer head warranty doesn't cover damage caused by third party inks.

Regardless of the type of black-and-white printing, you'll often find that the black-and-white photo looks its best with a thin, black border around it. This adds a very classy touch to the photo and makes it look more "artistic."

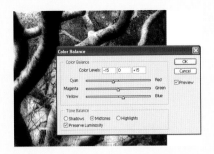

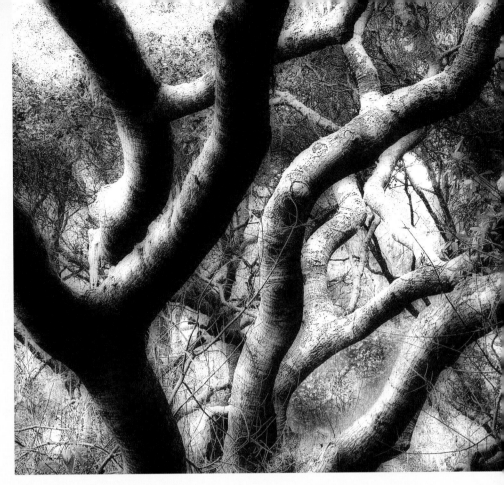

▲ If a black-and-white image is still in the RGB color space, it can be easily color toned with tools like Color Balance.

▶ A color tone can add an elegant touch to a black-and-white photo and make it print better on an ink jet printer.

Toning the Photo

If Ansel Adams could do it, why can't you and I? Adding a slight color tone to an image will give it more depth when printed as well as making it easier to print with four- and six-color printers. The easiest way to do this is to start with your black-and-white image in the RGB color space. You then use several techniques to add color:

1 Color Balance

Adjust the color balance to add yellow and red, for warm sepia tones, or cyan and blue, for cool selenium tones, to the photo. Experiment with the amount of adjustment as you make prints, then once you have a good print, record the adjustments for future printing.

2 Hue/Saturation

Use the colorize feature and change the hue setting to give you the color you want. Tone it down with the saturation control.

3 Color layers

Add an empty layer over your photo. Fill it with a blue or warm tone (e.g., yellow-orange), then change the layer mode to color. Tone down the effect by reducing the layer opacity (10-15% often works well).

4 Duotone effects

Change your image to Grayscale, then click on Duotone, if your program has it. You now select the type of tonality you want (e.g., duotone, tritone, etc.). You will see several "Ink" colors, starting with black. Click on the ink and choose a warm color to go with black for a sepia-tone effect or play around with colors for all sorts of effects. Then vary how each "ink" is used in the photo by clicking on the Curves box and changing the curve. There is a live update as you do this, so play until you get exactly what you like. This control allows you to mix colors in some rather unique ways. Personally, I like the first three effects best because they are more intuitive and easier to use.

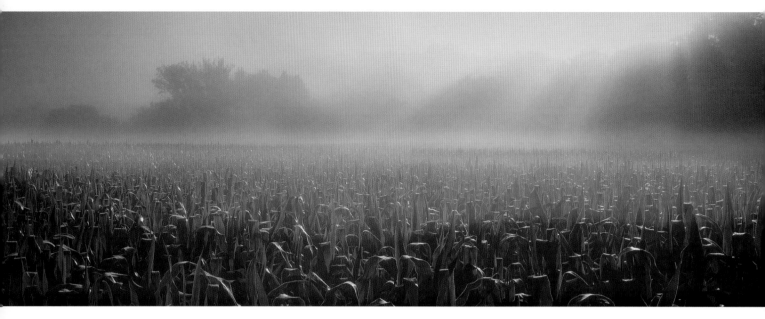

© Joseph R. Meehan

▲ **Panoramic photos are a great way to use an Epson printer because they can easily give you the proportions needed up to 44-inches long and more.**

Panoramic Photos

Wide-format, or panoramic, photos have long been popular with photographers. Yet, they were often hard to get made into large prints, and the specialized cameras needed for quality pans were expensive and scarce. Photographers have long tried taking multiple pictures of a scene, then lining up and pasting the prints together as a makeshift panoramic, but they could not blend the images together into one. The computer changes this dramatically. Anyone with a camera, film or digital, can now produce panoramic images.

Epson was the first printer company to offer ink jets that could print the long images that panoramic photos required. You can easily print photos up to the full width of the paper and 44 inches long (for standard printers) and with no length limit for the graphics printers. Panoramic images have gained popularity, because Epson printers have been available to print them.

Still, this doesn't mean any subject can be made into a panoramic. You need to compose for and shoot a composition that uses the entire image area effectively. Watch each side and the middle, as there should be compositional elements of interest throughout.

© Joseph R. Meehan

Shooting for Panoramics

To make a good panoramic print, you need to start with the right materials. You could shoot with a panoramic camera and scan the resulting negative or transparency. It will be too big for most film scanners, so you'll need to use something like a high-resolution flatbed scanner with transparency adapter, such as the Epson Perfection 2450 Photo scanner.

Many photographers are building panoramics from images shot with a standard 35mm or digital camera. To do this, you shoot a series of photos from one side of the scene to the other, overlapping each shot, and put them together in the computer. One advantage to this is that you can use the equipment you already have.

◀ **Panoramic images can be more than horizontal landscapes, too. The key to their composition is to be sure there is something interesting from side-to-side or top-to-bottom.**

© Bill Campbell

◀ **Even a standard Epson desktop printer can produce a big panoramic print.**

Here are some tips:

1 Plan out the panoramic

Figure out what the composition will include from right to left (or top to bottom if you are shooting a tall panoramic image). A panoramic needs to have interesting things happening from one side to another, with no dead space, to keep your viewer's attention.

2 Level your tripod and your camera

As you move across the scene taking photos the camera needs to move in a horizontal plane or the resulting images will be hard to line up. Do the leveling in two steps: tripod first, then camera. You will find everything lines up better if you use a tripod.

3 Overlap the images by 20-50%

More overlap can make it easier to line up the photos in the computer, especially with automated programs, but this also means you have to take more photos.

4 Shoot on manual

Your exposure needs to be optimized and limited to one setting through the entire sequence of images or the final pieces of the pan will be hard to match up.

5 Practice

There is no question that panoramic photography gets easier as you do more of it.

Once you have your shots, bring them into the computer. With a digital camera, this is a relatively straightforward step, as all the images should be identical in size. With film you need to be careful that you scan each image the same: same crop, same resolution, same size, everything the same. That will help you line up the images better in the software.

Stitching Programs

There are two basic ways of dealing with a panoramic image shot with multiple exposures. You can use a stitching program that does the work for you, or you can use image-processing software that has layers and you do it yourself. There are advantages and disadvantages to each method. Stitching programs (such as ArcSoft's Panorama Maker, www.arcsoft.com, or the Photomerge option in Adobe Photoshop Elements, www.adobe.com) are very easy, but need distinct objects in the overlapped areas in order to work best. In addition, they should have a healthy overlap (30-50%) to do their stitching of images. They usually have some "morphing" capabilities that allow the images to blend better where things don't match perfectly.

With a stitching program, the steps are pretty straightforward. First, you need to check all of your photos to be sure they are consistent in size and tonality. Any big changes in brightness, for example, will show up as unevenness in the final image. Make any adjustments needed to give them the required consistency, before you try to stitch them

▲ These two photos were shot with the deliberate 30% overlap, so they could be more easily stitched together in a panoramic shot.

ArcSoft's Panorama Maker is an inexpensive, semi-automated way to create panoramic prints. ▶

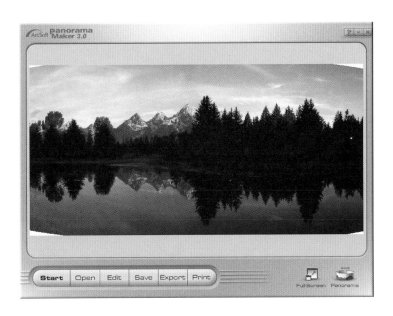

together and then import them into your stitching program. While some programs claim to be able to figure out the order of your photos automatically, you can usually help the program work more efficiently, if you put the pictures in order from left to right (or top to bottom).

Then you tell the program to go to work. Depending on the processing speed and RAM of your computer, this will take a little time. RAM is really

critical as panoramic photos can get quite large. Once the processing is complete, take a look at your photo. You may find a section giving you a problem with uneven tones. You may have to go back and adjust that photo, then redo the panoramic. Minor problems can often be corrected with the cloning tool. You'll usually have to do a crop to the final image to fix the edges.

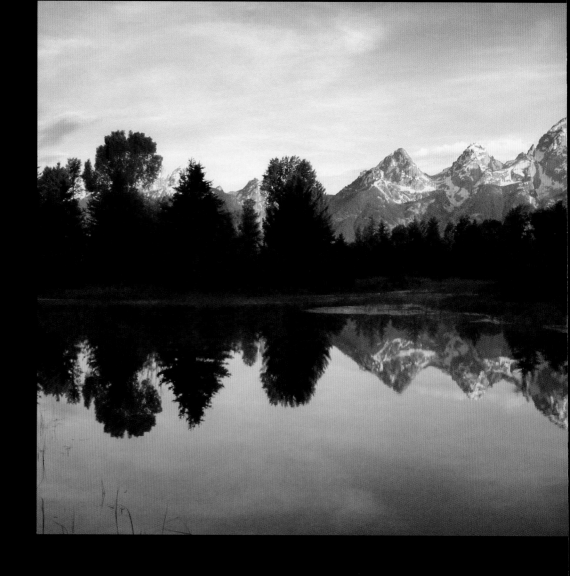

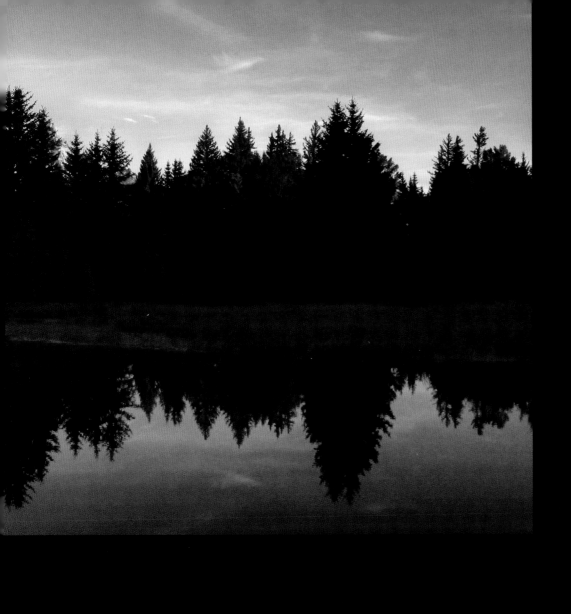

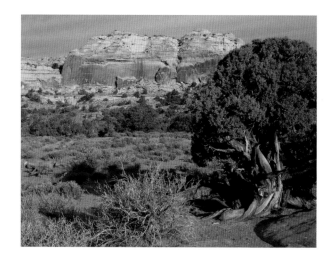

▲ A strong graphic element in the overlap area of photos that are used for a panoramic image will help you put them together.

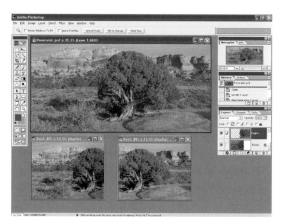

◀ With imaging programs that offer layers, you can carefully control how your panoramic shots come together.

Layered Panoramics

Using layers to build a panoramic does take more work, but they can be more effective when you have less overlap, the overlap is not distinct or you have movement between shots. In the last case, you need to make some decisions as to what to keep and what to leave out in the overlapped areas that the automated stitching programs won't make.

Layered panoramics can give you more precision in matching pieces of the image, too. You'll have the easiest time if your program includes both layers and layer masks, such as Adobe Photoshop. These added layers do increase the demands on your system, so need to be sure you have enough RAM. Most photographers find that 512 MB is a comfortable minimum unless you are making really big pans. The steps are as follows:

1 Bring your images into the software. Here is where a digital camera really shines, because, as long as you were careful in how you set up the camera, the photos will line up as expected.

2 Create a blank page that is slightly larger than your photos' depth and as long as the total number of photos times their width. For example, suppose you have a 5 x 7 inch size for a single image and three total images for the panorama. The blank page should then be about six inches deep (this covers the five inch side) and 21 inches long (to include all three photos lined up). You won't actually need the full width, because the photos overlap, but it helps to have the working space when you are beginning.

▲ **The final shot now ready for printing.**

3 Drag or copy and paste the photos on to the blank page. Each will go on separate layers.

4 Starting with the left photo from the pan series, move it to the far left of the working layered panoramic and make it the bottom layer. Then move the next image to the left until it overlaps the first in approximately the right alignment.

5 Make your overlapping layer somewhat transparent and move it around until it lines up with the first layer as best as you can. It might not be perfect, but that's okay. Now, make it opaque again.

6 Blend the edge of the two layers together by removing parts of the top image, letting the good parts of the lower image show through. If your program includes it, a layer mask is the best way to gain control over the removal

process, including being able to bring back things that you took out by mistake. Try using soft brushes in your layer mask. Soft eraser tools on programs without a layer mask can help, too, although they often require a lot of "doing and undoing" to get it right. Work until the two photos look as one. You may need to do some minor corrections with the clone tool.

7 Repeat the process for each individual image of the panoramic series.

8 Fix the edges. It is rare that all of the individual shots will line up exactly. Use your crop tool to trim the edges and complete the panoramic.

9 You can then do your normal finishing touches to an image, such as flattening and sharpening the image with your standard Unsharp Mask settings.

Panoramic Skies

The sky part of a constructed panoramic photo is one place where you will often run into problems. This is one area where inconsistencies of tone can really make an otherwise good photo look bad.

Probably the easiest way to fix skies is to use a combination of selections and layers. Let's look at how you would do this to replace an entire sky. This is easiest to do with a small sky area without clouds (which will show problems more, anyway).

1 **Select the sky**

Use the Magic Wand selection tool or other automatic edge selection tools. Select the whole sky, even if you have to do it in stages, adding in parts from different layers. You may need to add a very slight feather (just a few pixels) to blend the edge

2 **Choose sky colors**

Pick up colors from the original sky. In Photoshop and Photoshop Elements, you can select a foreground and a background color. Double click on the color icon and you will get the Color Picker. Move your cursor over the pan sky and it will turn to an Eyedropper. If there is any color in the sky at all, click on a dark color for the foreground and a light color for the background, since most skies blend from dark to light as they get close to the horizon. Otherwise pick good sky colors from the Color Picker palette.

3 **Fill the selection with the sky colors**

Using the Gradient tool, create a gradient of your sky colors from dark to light through your selected sky area, keeping the dark at the top and the light at the bottom. Experiment with your positioning of the start and stop points of your gradient line. You work a gradient by clicking once to start the gradient, then, keeping the mouse button depressed, you move to a new spot where the gradient will end and release. The gradient will blend over that distance.

4 **Adjust the new sky color and tone**

Use the Hue/Saturation and Brightness/Contrast controls to make the sky look natural.

5 **Use layers for more control**

If you make this new sky on a new layer, you gain a lot more control. You will be able to blend the edges easier as well as adjust its color and strength without affecting anything else. You may also find that experimenting with Layer Modes will help.

6 **Add noise to the sky**

The new colors are smooth and don't look very photographic. Enlarge a section of the photo so you can see the grain in the non-sky part of the photo and add some noise to the sky colors (in the Filters menu) to match. Usually, you set the grain very low and you may even need to add a slight Gaussian blur to it to make it match the rest of the photo.

Printing the Panoramic

Once you complete your panoramic image, you'll want to print it out on your Epson printer. This is not a problem except that you need to have long paper. You can buy Epson photo-quality paper in rolls that can be either used with a roll feeder or cut to be single-sheet fed into the printer. You can also buy sheets of paper precut to a standard panoramic size of 8.3 x 23.4 inches.

When you print, you do need to tell your printer what kind of paper it is and the size. Obviously, a very big panoramic will take some time to print. Be careful to support the paper carefully both going into the printer and coming out so it does not fold or crease and damage your photo.

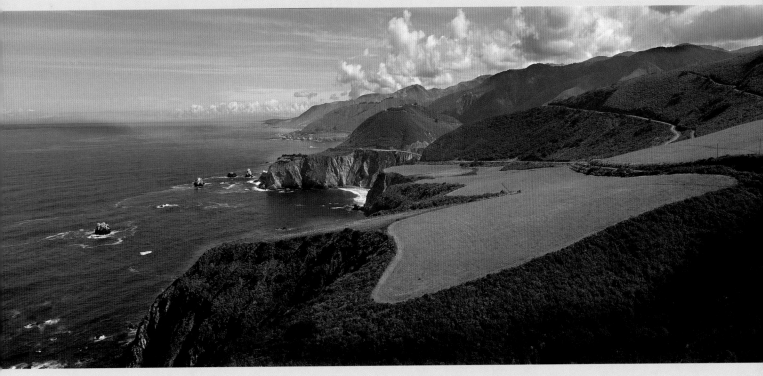

© Joseph R. Meehan

© Joseph R. Meehan

© Joseph R. Meehan

© Joseph R. Meehan

© Joseph R. Meehan

Photographer

Joseph R. Meehan

Panoramics and More

Joe Meehan's specialty is large panoramic photography. He is also a well-known photography book author who speaks at seminars across the country and is technical editor of *Photo District News*. "All the Epson photo printers are a blessing because they will print panoramic prints," he says. "In the 6 x 17, 1:3 aspect ratio format, for example, this means being able to make a stunning color print measuring roughly 1 x 3 feet in size, from a machine costing less than a good SLR."

He started using Epson printers when the first photo model was introduced. "Back in those days, there were no ink jet photo-type papers available, so I would process unexposed black-and-white resin-coated conventional print paper in my darkroom, and then use it in the Epson to get a photo print look."

Today, Meehan has a wall of Epson printers for a whole variety of purposes, from print sales to illustrations for his seminars on digital print output. He uses prints as final art for the books he writes on photographic methods. His favorite papers include Epson's Premium Luster, ColorLife, and Heavyweight Matte paper.

Years ago, he would spend hours in a darkroom or farm out volume printing to a lab. Now, virtually all of his color prints are made on Epson printers, which often run continuously while he does other things in his office.

"Doing your own printing opens up all sorts of chances to experiment, which is why I always maintained a darkroom in my commercial business. But the ease with which I can now print out four or six variations of the same image on an 11 x 17 sheet of ink jet paper in a matter of a few minutes surpasses anything I was able to do previously in my darkroom. This ability has really expanded the whole creative process for me."

He has also started to present clients with variations, which he says they really appreciate. Meehan says that the ink jet printer has now given him complete control over the whole creative process with a level of speed, convenience and range of variations that he has never experienced before.

"The handwriting is really on the wall," Meehan says. "Digital printing is gaining in acceptance among photographers, art buyers, and publishers. In fact, it is now considered to be a form of high-quality print making. In addition, the ability to use different papers and ink sets offers more opportunities to achieve a personal interpretation than any other form of printing."

Meehan's Web site is www.josephmeehan.com.

Long-Lived Prints

When ink jets first came out with photo-quality printing, they had a real limitation, as the dyes used for the colors faded. With some of the earliest photo-quality printers, this life was as short as six months. Ink jet printers rivaled traditional prints in color and tone, but not in longevity.

The life of a print was a serious issue for photographers. They wanted to be able to display photos for longer than a few months, and they wanted to give away, or sell, prints that could be enjoyed for years.

Epson was the first manufacturer to address this concern of photographers. The company came out with dye-based inks that would last as long as traditional photo prints when used with the appropriate papers. This was a major breakthrough.

Next, Epson came out with pigment-based inks that actually would work in an ink jet printer and not clog the heads (a problem with that type of ink). These inks could last over 100 years. Although they weren't quite up to the colors of dye-based inks, they were really quite good. Of course, Epson has gone beyond that now, offering both dye-based and pigmented inks with brilliant color and very long life.

Archival Qualities

The term archival has been thrown around in the industry to mean a lot of things related to longevity of an image. Loosely defined, archival refers to the life of a print when it can look its best over a significant amount of time without noticeable fading or color shifting. The arguments will reign on exactly how long this must be and what is noticeable fading or color change. This change is mostly influenced by light, but there also can be effects from gas or humidity.

Rather than getting into a debate about the precise definition of "archival," I think it is most useful to look at the key factors influencing the life of a print. There are basically three things that can affect how long a print will remain looking its best without significant fading or color shifting: ink, paper, and storage method.

Ink and Paper

Epson uses two basic types of inks: dye-based and pigmented. Printers based on Epson pigment-based Archival Photo Inks resist fading longer than any dye-based inks. However, with the right paper, dye-based inks will retain their colors for a long time. The latter do provide some advantages in printing speed and the highest color gamut or range.

With Epson's dye-based photo inks, you can expect a print to resist fading (Lightfast rating) for over 20 years when Epson Matte Paper Heavyweight is used and seven years with standard Epson Photo Paper. These are well within the range of life of traditional color prints from the local minilab.

Life of typical displayed and framed Epson prints, based on independent testing from Wilhelm Research Labs (www.Wilhelm-research.com):

Epson Photo Paper Type	Dye-based Inks	DuraBrite Pigment Inks	Ultrachrome Pigment Inks
Premium Glossy	5 years	28 years	50 years
Premium Luster	6 years	27 years	47 years
Matte Paper Heavyweight	18 years	72 years	. . .
Archival/Enhanced Matte Paper	. . .	54 years	62 years
ColorLife	27 years
Radiant White Watercolor Paper	90 years

Note: Ink types are dependent on specific printers and cannot be interchanged among printers.

◀ **Choosing the right paper will affect the life of your print.**

▶ **Archival storage is essential for long-lived prints. These metal-edged boxes from archivalmethods.com feature a removable top with hinged, drop-front panel on the long side. This opens the box so that dog-earing is minimized.**

When Epson's UltraChrome inks are used with Epson matte-type papers or Epson Premium Photo Papers, expect them to last decades without fading. Epson's DuraBrite Ink is a pigment-based ink used with certain Epson four-color printers and has similar qualities, but is not used with photo printers.

The ratings here are based on accelerated testing of prints displayed indoors, under glass, under fluorescent lights. Severe conditions, such as prints under direct sunlight, may cause shorter lives.

Image Storage

The better the conditions a print is stored in, the longer its life will be. Typically, dye-based prints can stand handling better than pigmented inks, because they are absorbed into the paper. While quite durable, pigmented ink surfaces are more easily scratched and damaged than dye-based prints.

If a print is kept out of the light, in a protected album or other storage container, you can expect a very long life indeed. The album or storage container, however, should be made of archival materials (such as acid-free paper), so that it doesn't interact with the prints.

On display, a print should be framed and kept behind glass for longest life. Be sure the framing materials, such as the matte and mounting boards, are archival quality, or acid-free. And remember that display in bright sunlight or near fluorescents will shorten a print's life.

◀ **Properly stored, Epson ink jet prints can last a very long time.**

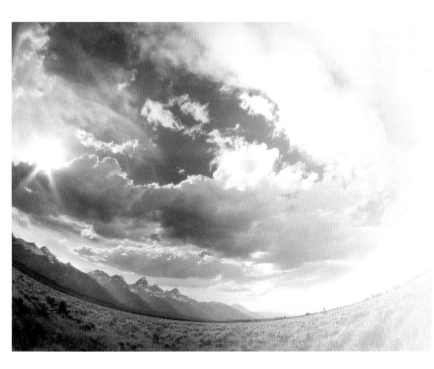

◀ **A faded photo is never fun. Use the right printer and papers, frame your photos and store them well to ensure their longevity.**

© Greg Gorman

© Greg Gorman

© Greg Gorman

Greg Gorman

Celebrity Personalities

Greg Gorman is one of the most sought after and respected photographers in the industry. From personality portraits and advertising campaigns to magazine layouts and fine art work, Gorman has developed and showcased a discriminating and unique style in his imaging. One of his strengths has been photographing noted motion picture and music personalities, as well as icons from the sports world. His work has been used for feature film advertising and publicity campaigns as well as album covers. In addition to gallery exhibitions, Gorman's work has been exhibited in museum shows in North America and Europe and is consistently featured in publications throughout the world.

In 1968, knowing little about photography, Gorman borrowed a friend's camera to take some pictures at a Jimi Hendrix concert. When he saw the images coming up in the developer tray, he was hooked on photography. Gorman says he still gets excited every time he takes a picture. Over the past few years, what has really captured his attention is the digital revolution.

Gorman uses both desktop and large format Epson ink jet printers to print his images, and he says they have changed his career. The digital revolution has allowed Gorman to go back into the darkroom, which is something he hadn't done in 30 years. Except this time it's a digital darkroom. He has found that working digitally is quicker, more efficient, and more effective than the traditional analog process.

"I get incredible quality with my Epson printers, and I'm in complete control," Gorman says. "I can see my vision from the concept to the finished product, whereas before I was relying on lab technicians to try to give me what they thought I wanted. Now I have complete control. Nothing is more satisfying than seeing my image come off the printer the way I perceived it."

In addition to the right printers, the right ink and paper are critical for Gorman's work. He looks for high contrast, deep, saturated colors, strong blacks, and good shadow detail, and he needs images that will last. He says Epson's seven-color UltraChrome inks, which are pigment-based, give him the strong blacks he wants in his prints, along with permanence.

"I want my prints to be around long after I'm gone. With Epson printers I get images that not only will look great but also will last for generations."

Caring for your Printer

Your Epson printer will provide excellent service to you for many, many prints. But like all mechanical and digital devices, wear and tear, as well as computer conflicts, can cause problems.

The life of a printer depends on your printing needs. There is no question the expensive graphic arts ink jets, which often have similar printing specifications to much lower priced units, will print a volume of prints every day without failure much longer than a value-priced printer. You do get what you pay for. However, if you only print a few photos per week, you probably don't need a high-priced printer designed for the graphic artist, or wedding photographer, who cranks out lots of photos.

In addition, you may want to upgrade your printer, if new technology offers something valuable to you. Seven-color printers, for example, are a real boon for black-and-white printing. So, if you want to do a lot of that type of printing and only have a four- or six-color printer, it may be an excellent investment.

Regardless of your printer, there are some things you can do to keep your Epson printer working at its best. Your printer's manual will cover much of this in more detail specific to your unit than I can do in the book, but I will give you some hints on maintaining your printer.

On and Off

This seems like such a basic thing. How can be turning a printer on and off be a problem? It isn't unless you turn it on and off from a power strip. Never do that. When you turn a printer off, it parks the heads in a very specific place. If you turn the printer off at a power strip, it may or may not be parked properly. This can lead to the head drying out and clogging.

If you are using the printer on a daily basis, you can just leave it on. You should turn the printer off if it is not going to be used for a few days. This allows it to park its heads, which maintains them properly. However, your printer does work best when used regularly, so turn on your printer and make a small print at least every couple of weeks (if not more often) to keep it functioning well.

▲ **Know your printer's controls and always turn it on and off with the power button.**

Print Head Cleaning

One of the most common problems with ink jet prints that don't look right is a clogged head. Typically, you'll see streaks of colors or actual lines of white where ink did not print. I've even seen clogged heads that printed oddly colored photos. This can also happen when your ink is low, so check that.

To fix a clog, you need to clean the print head. This will use up some ink, so, you don't want or need to clean a head until it shows a clog and really requires the cleaning. When it does, cleaning is well worth this small sacrifice.

On Epson printers, you can clean the head in two ways: on the printer or through software. There is a cleaning button on the front of the printer (check your manual for exact placement). Hold it down for three seconds and the unit will start a cleaning cycle.

There is a head-cleaning utility in the software. You get to it through the printer driver. You can right-click the printer icon in the Windows taskbar (or get to it through the Start menu, Settings, and Printers) and select Head Cleaning. Or, open the File menu in a Mac and choose Page Setup or Print. Then you click the Utility and Head-Cleaning buttons in that order. Follow the on-screen instructions.

▲ **A clogged printer head (left photo) quickly degrades image quality.**

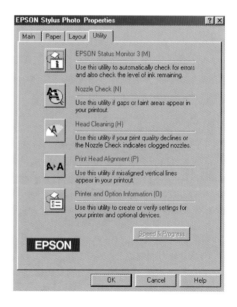

▲ **All Epson printer drivers have a utility section for printer maintenance.**

◀ **In this detail, you can see how a clogged head printed blacks poorly (left image).**

Whichever technique you use, the printer will make a bit of noise while it works. This is normal. The green power light will flash while it is working. Be sure that you do not turn the printer off while it is cleaning its heads.

Once done, you should use the head-cleaning utility to check the nozzles on the head. Click on Print nozzle check pattern, then Print. Check your page when it comes out. If the printed pattern is nice and solid with no gaps or lines, the head is clean. If it is streaky, try cleaning again.

If you do this a few times and you still see streaking, you can try turning the printer off and letting it sit overnight. According to Epson, this allows dried ink to soften. Then try cleaning again. You may also find that the old ink cartridge just isn't helping. You can install a new one and the heads may clean better.

Clogged heads can come from using non-Epson ink cartridges. Epson wants its customers to have success with their prints, so they have a very high standard of ink quality. Not all independent cartridges will meet those standards. This can be a big problem because the head is built into the printer and cannot be easily cleaned if clogged by bad ink. So, to minimize clog problems, use Epson ink.

Aligning the Print Head

You may never have to align your printer's head. This is not a preventative maintenance procedure. You only need to align the head if your prints show vertical lines that don't connect.

Print head alignment is done through the Epson printer software, so the ink jet must be connected to the computer. Open the printer utilities as described above, but instead of choosing head cleaning, you will choose the Print Head Alignment button. From here, you follow the instructions on the screen. You will be making a test print then choosing lines that look most precisely aligned. I find that this is best done quickly. If you agonize over the choices, it can be really hard to see the differences.

Cleaning the Printer

A printer gets dusty over time. To keep it at its peak, clean it a few times a year. This is a pretty simple thing to do, but be sure you disconnect both the power plug and the computer cable before starting.

Use a soft brush to clean dust and dirt from the sheet feeder. You can use the same brush inside the printer, but avoid the gears. A can of compressed air can be used to get rid of dust and debris, but never shake it or get the nozzle too close to moving parts. Clean ink out of the inside of the printer with a soft, slightly damp (not wet) cloth. Use a soft, slightly damp cloth on the outside as well.

Never use any solvents or oils, especially cleaners with alcohol, as this can damage the plastic. Don't use the cleaning sheets that sometimes come with printing papers as these can actually cause problems, including jamming inside the printer.

Troubleshooting—Common Printer Problems

1
Driver problems
It is possible to have your driver fail to work properly in any number of ways. Removing it and re-installing the driver can help. In addition, it is always a good idea to check Epson's Web site every once in a while to see if a new, improved driver or software patches have been posted.

2
Check your manual
I know, the joke is that we never bother with the manual. Yet, Epson manuals have an excellent troubleshooting guide that goes far beyond the scope of this chapter, plus it is specific for your printer.

3
Run a printer check
It can be useful to know if the printer or the computer is the source of any problem. Turn off the printer and computer then disconnect the printer. Hold down the maintenance button (check your manual), and while still holding it down, push and release the power button. Keep holding the maintenance button until the green power light flashes. The printer will now print a test page. If it prints okay, then the problem is most likely in the computer or in the cable connection.

4
Printing seems slow
Check your image size. Big, high-resolution images need RAM and hard-drive space to print. Be sure you have enough of each. You may need to add both, but RAM is especially important.

5
Banding or splotchy colors
Be sure you have the right paper and driver setting. Some non-Epson brands can print very poorly in this way. In addition, if you load some papers in upside down, you will get some quite odd ink patterns on the photo. If the paper and driver setting is right, try cleaning as mentioned above, or you may need a new ink cartridge.

6
Faint or low contrast prints occur
This can come from a number of sources, including clogged ink heads. However, most often, this problem is caused by the use of the wrong printer driver setting and the wrong paper. It can also come from old ink cartridges or old paper.

7
Prints look grainy
This may be a function of the image, so check to see that you aren't seeing real grain or digital noise (see Grain Management in Chapter 8 for more information). This can also be an issue of trying to print an image at too small a file size for the print. This will result in a low image resolution that may create unintended grain effects.

8
Paper jams
Some papers want to stick together and jam. Try fanning them in your hand before loading the printer. Also, be sure the printing surface is up. You may find that you can't use some papers, or you may have to use specialty surface papers one at a time. Be careful not to overload the paper feeder.

Index

Notes